SECRET
ALDEBURGH TO
SOUTHWOLD

Terry Philpot

AMBERLEY

About the Author

Terry Philpot has written and edited twenty-two books, including *31 London Cemeteries to Visit Before You Die* (2012), *Beside the Seaside: Brighton's Places and Its People* (2015), *Secret Lewes* (2017) and *Secret Rye & Around* (2017). He has contributed twenty-one entries to the *Oxford Dictionary of National Biography*, writes regularly for *The Tablet* and has written for a wide range of publications.

To Simon Rodway and Tony Inwood, with so many happy memories of 'the cottage'.

First published 2018

Amberley Publishing
The Hill, Stroud
Gloucestershire, GL5 4EP

www.amberley-books.com

ISBN 978 1 4456 7406 3 (print)
ISBN 978 1 4456 7407 0 (ebook)

British Library Cataloguing in Publication Data.
A catalogue record for this book is available from the British Library.

Origination by Amberley Publishing.
Printed in Great Britain.

Contents

Introduction

Suffolk, particularly Southwold to Aldeburgh, still retains a beguiling, largely unspoiled remoteness. The flat landscape is dotted with farms, the big sky illuminates the littleness of life, and the ruined abbey and castle bespeak a rich past.

In traversing this landscape, I confess to a personal connection, which has enhanced the pleasure of writing this book. The novelist Maggie Hemingway was born in Orford but moved to New Zealand when she was a small child and later settled in Deal in Kent. Yet, when she crossed the Stour at Manningtree on the train, she would say, 'Now I'm home.' My attachment is more distant, but nonetheless deeply felt. My paternal great-grandfather moved to London in the 1860s, leaving behind the ghosts of generations who had lived in the part of the county that is the subject of this book. The names of the villages through which I have often passed are redolent of family births, marriages, burials and places of earning a living (or sometimes not). My great-great-grandparents were married at Wenhaston in the church of the great doom painting, though they could never have seen it for at that time it was still hidden beneath Edward VI's Protestant plaster. I have been coming to this area for forty years and whenever I cross the Essex-Suffolk border I still experience something of Maggie Hemingway's sense of homecoming.

So far as people are concerned, I have attempted to write of the subject's association with the town or village, rather than offer a potted biography of their lives. Alas, in some cases, there is nothing to say as I could trace no more than a birthplace – like that of the great documentary film-maker Humphrey Jennings (Walberswick) and the Victorian photographer Robert Howlett (Theberton). While P. D. James had a home in Southwold and also set some of her books in the county, she wrote an entertaining and charming memoir, *Time to be in Earnest*, but this tells very little about her Suffolk life, other than that she entertained family and friends and was a regular communicant at St Edmund's Church. (Her fellow crime writer, Ruth Rendell, lived in Babergh, which is outside the geographical scope of my remit.)

With two necessary exceptions, I have drawn a line by writing about only those who are dead. Ronald Blythe, happily still writing at ninety-three, is inextricable from what I call the Aldeburgh Festival Circle. A later friend of Benjamin Britten and Peter Pears (she met them in 1971, only five years before the composer's death) was the then young but accomplished novelist Susan Hill.

Fortunately, the biographies of buildings and places are (usually) far less well-hidden than those of people, but there were many discoveries there too – even in an area already well mapped.

The reader or visitor asks: Who? What? When? Where? Why? Whether events, buildings or people are familiar or obscured I have attempted to answer those questions and, in so doing, reveal their secrets.

1. Shaped by the Sea: A Very Short History

Both Southwold and Aldeburgh have long ceased to be prosperous ports, but Dunwich, now no more than a hamlet, was at one time greater than either of them. The sea has shaped the destinies of all three, and particularly so Dunwich, which was a major settlement in Roman times, like Ipswich and Colchester. Now most of what was an impressive place even long after the Romans had left is below the sea.

Dunwich

This decline of Dunwich has left it with a strange eeriness. Had we arrived in Dunwich with the Romans, who may have built a fort here, we would have seen a coastline a mile further out than one sees today. Although the Domesday Book records 3 churches and 236 burgesses (then freemen), even by that time a large part of the land had been lost to coastal erosion.

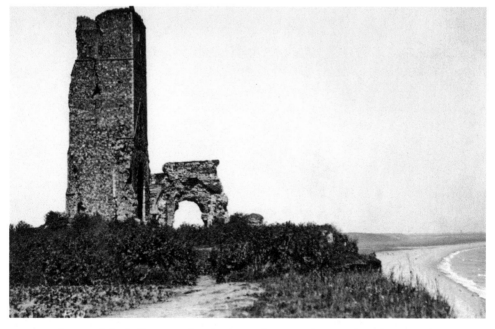

By 1910, what was left of All Saints Church, Dunwich, was in danger of toppling into the sea, as it did twelve years later. (Courtesy of Michael Rouse)

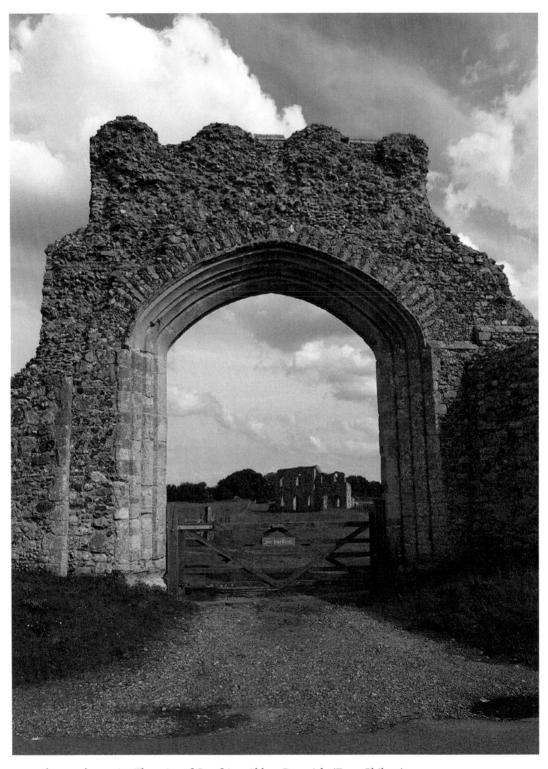

Above and opposite: The ruins of Greyfriars Abbey, Dunwich. (Terry Philpot)

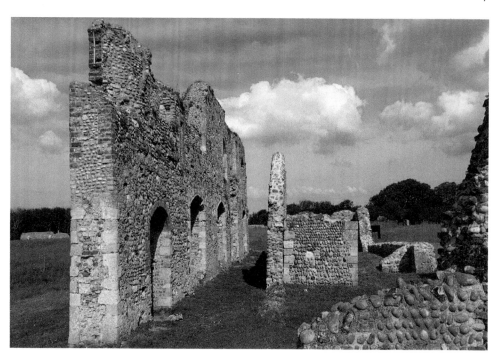

Roman settlement expanded it to a sizeable town and seaport, linked to the growth of the North Sea fishing industry. By 1225 Dunwich, with eight parishes, was the size of a city. It was a town set upon low-lying hills, with eight churches, three chapels, five religious houses (including Franciscan and Dominican monasteries), a preceptor of the Knights Templar, two hospitals, and there may have been a mint and a guildhall.

DID YOU KNOW?

Scorch marks on the inside of the door facing the porch entrance in Holy Trinity Church, Blythburgh (*see* Chapter 2), are said to have been made by the Devil, who appeared on 4 August 1577 in the form of Old Shuck, a fiery-eyed black dog who terrorised East Anglia. The dog ran down the aisle and killed two people and, on his way out, brought down the steeple. That same year two people died when lightning struck and the tower collapsed through the roof.

The legend says that on the same night, Old Shuck left many dead at St Mary's Church in Bungay – 12 miles away. But there, while the story of the Devil incarnate persisted, some also claimed the dog was the ghostly presence Hugh Bigod, an evil local landowner who had wrought terror on the residents 300 years before. The dog today sits atop Bungay's coat of arms.

There were alleged sightings of Old Shuck in Bury St Edmunds in 1814, and also in Barham (near Ipswich) in 1946.

However, the devastation by the storms of 1286 swept many of the town's buildings into the sea and the Dunwich River became partly silted up. A storm in 1328 took what remained of the harbor, and Walberswick succeeded as the port.

Many people left; by 1540 the coastline was at the marketplace and forty years later half the town was lost. The erosion continued until in 1922 the tower of All Saints, the last of the village's medieval churches, toppled into the sea from its clifftop position, which it had reached in 1904.

There is little left surviving that speaks of the metropolis that once was Dunwich: Greyfriars Priory is in ruins, and all that remains of the twelfth-century St James' Leper Hospital can be seen on a north-facing slope within the churchyard of St James'.

The 'scorched' door in Holy Trinity, Blythburgh, and a detail of the marks. (Colin Huggins)

Southwold

Southwold's growth as a busy fishing port was halted when a shingle bar built up across the harbour mouth. However, two remarkable events have also shaped the town. The first was in 1509 when Thomas Godyll donated the common area, which has been preserved for 600 years, to the town. It was – by then, anyway – a place of some standing, for Henry VII had granted it a charter in 1489.

The second event was the fire of 1659, which bequeathed the series of 'village greens' to the town where houses, shops and other buildings once stood (*see* Chapter 7).

People from Southwold were among the 667 emigrants from East Anglian places like Aldeburgh, Framlingham and Wenhaston, who were among Puritans for New England from Ipswich and Southwold ports. There were eighteen in a 'company' under Revd Young, who set off on the *Mary Ann* in 1637 and founded Southold [*sic*] on Long Island. They were often interrelated. Thomas Moore from Southwold married Young's daughter, Martha. Richard Ibrook, in another party, was born in Southwold and was a former bailiff (a local official) of the town. He went to Hingham with Revd Peter Hobart, who had graduated from Magdalen College, Cambridge, to become an assistant vicar of St Edmund's Church, Southwold. In his newfound land, Hobart married Ibrook's daughter, Rebecca.

The Battle of Sole Bay occurred in 1672, the first naval battle of the Third Anglo-Dutch War. The English and French fleets combined seventy-one warships to meet the sixty-one commanded by the Dutch, a clash that occurred just offshore. It is said that 50,000 men took part in the battle. The Lord High Admiral of the English fleet was James, Duke of York, brother of Charles II, who set up headquarters and stayed at Sutherland House, High Street (which dates from 1455 and was the home to the merchant Thomas Cammel) and from there directed operations. He was joined by the Earl of Sandwich, who died in

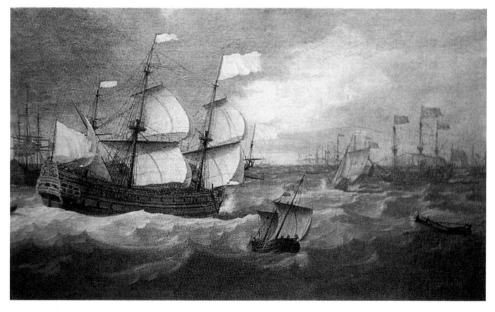

The French ship *St Philip* at the Battle of Sole Bay in the painting by Jan Karel Donatus Van Beeck.

Sutherland House, Southwold, where James, Duke of York, had his headquarters during the Battle of Sole Bay. (Terry Philpot)

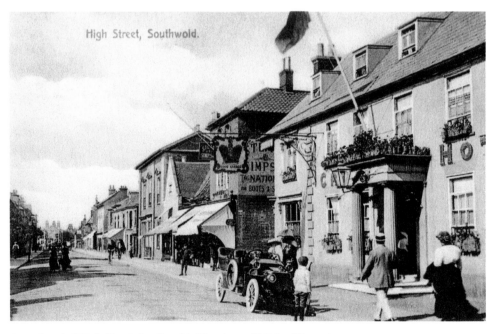

An unhurried High Street, Southwold. (Courtesy of Michael Rouse)

the battle. Matthew Wren, cousin of Sir Christopher Wren, an MP and James' secretary, was fatally injured in the battle, dying at Greenwich. (The plaque on Sutherland House erroneously refers to James Wren and fails to mention that he died as a result of the battle.)

A reminder of such clashes can be seen today at Gun Hill with its 18-pound cannons. These are believed to have been given to the town in 1746 by the Royal Armouries to protect shipping against raids. They were last fired in 1842 to mark the birthday of the Prince of Wales, during which exercise a man was killed during the reloading.

Aldeburgh

The name of Aldeburgh derives from 'old fort' and the Roman site is beneath the waves. There were Saxon settlements here and excavations at nearby Snape during 1862–63 revealed a boat grave, the first from the Anglo-Saxon period ever recorded in England. There was a gold ring (now in the British Museum) and the boat contained a glass claw breaker, other jewellery, buckles and materials, which suggests it was a place of some importance. There were also a number of Anglo-Saxon cremation mounds.

Aldeburgh's history is largely obscure until after 1500, when the small finishing village was favoured by a shifting coastline that created a sheltered haven, which saw the growth of shipbuilding and trade. Such growth was recognised by its grant of borough status and a degree of autonomous government by Henry VIII in 1529. At the time of his daughter

Aldeburgh seen from local artist Maggi Hamling's scallop shells sculpture on the beach that commemorates the life of Benjamin Britten. (Terry Philpot)

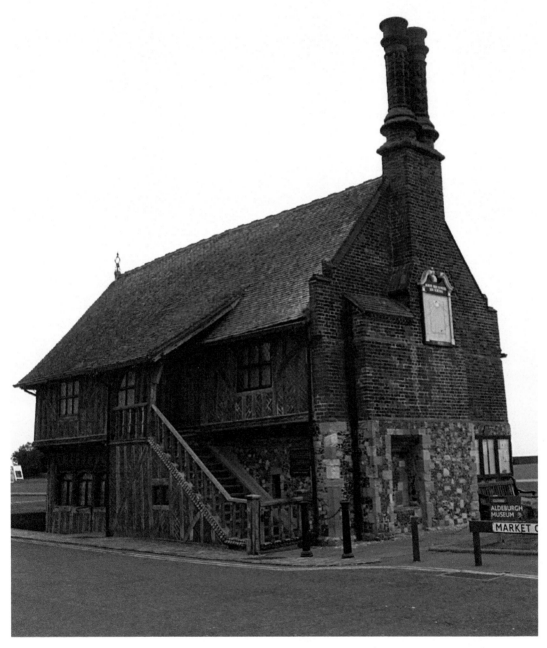

Aldeburgh's Moot Hall 'standing as a beautiful Tudor toy', according to Ronald Blythe. (Terry Philpot)

Elizabeth's rule, two of Sir Francis Drake's ships – *The Greyhound* and the *Golden Hind* – were built in the town. In 1571 the right of its freemen to elect two MPs was granted.

Aldeburgh has nothing of the dramatic history of Dunwich, and as the River Alde silted up its importance as a port declined. But, as the uneventful centuries since its shipbuilding days passed, Aldeburgh's popularity as a resort grew in the nineteenth century, and that period largely dates the Aldeburgh we see today.

DID YOU KNOW?

Early in the morning of 17 June 1917, sixteen German airmen of the nineteen-man crew died when Zeppelin L48 was shot down on a bombing raid over Holly Tree Farm, Theberton. Their memorial is a simple metal one, set in wood, in the small churchyard across the road from St Peter's Church. A piece of the airship is in a glass case in the porch, together with old newspaper photographs of the incident. The men's remains were later interred at the German war cemetery at Cannock Chase, Staffordshire.

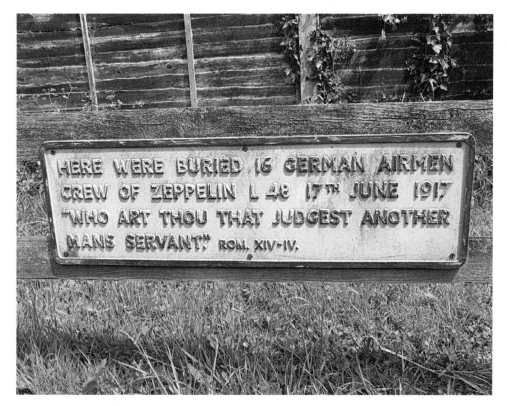

The memorial in the churchyard of St Peter's Church, Theberton, which is dedicated to the German airmen who died when their Zeppelin came down over the village. (Terry Philpot)

DID YOU KNOW?

Joseph P. Kennedy, son of the former American ambassador to the United Kingdom of the same name, and eldest of the Kennedy children (who included the famed president) died in a wartime air accident near Blythburgh in 1944.

A lieutenant flight commander was stationed at Dunkeswell airbase in Suffolk and taking part in Operation Aphrodite, which used unmanned planes. They could not take off safely on their own so two crew members went with them and, having activated remote control at 2,000 feet, parachuted out.

Twenty-eight minutes after take off and Kennedy gave the code 'Spade Flush' (his last words) to indicate remote control; there was a sudden gasp, followed by a huge fireball and an explosion that was so great that it damaged aircraft flying support, forcing them to land. Wreckage landed near Blythburgh, causing widespread damage and small fires, but no one on the ground was injured. One report claimed that there was damage to fifty-nine buildings elsewhere.

The last photograph believed to have been taken of Joseph P. Kennedy.

2. Places Apart

The Howard Tombs, St Michael the Archangel Church, Framlingham

The Howard tombs are not only the resting place of some members of one of the country's most historically significant families, but works of funerary art that vie with those found anywhere else, including in continental Europe.

Framlingham Castle was once the stronghold of the Howards, Dukes of Norfolk. Their tombs being here is itself historically significant because they were removed from the Cluniac priory of St Mary's in Norfolk – mostly after Henry VIII's Dissolution. Once one of the largest religious houses, the abbey is now a picturesque ruin, and so the tombs might so easily have been lost.

With the prospect of the house being destroyed, Thomas Howard, 3rd Duke of Norfolk, wrote to the king stating who was buried there and suggesting that the house be converted to 'a very honest parish church'. To this Henry initially agreed, but, ever mercurial, he changed his mind: the priory would be dissolved.

The 3rd Duke was the greatest nobleman of his day. He was uncle to both Anne Boleyn – over whose trial he presided in 1535 – and Catherine Howard. Several members of his family were in the Tower of London as a result of Henry's displeasure with Catherine. The duke was a powerful member of Henry's court until he was later charged with treason,

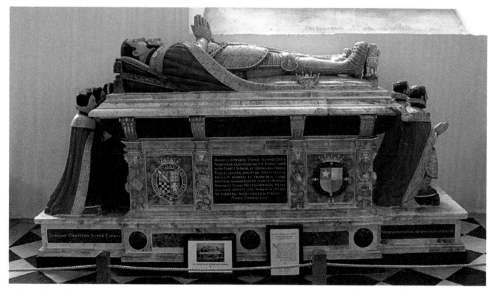

The tomb of Henry Howard, Earl of Surrey, Framlingham. (Courtesy of Steve Parker under Creative Commons 2.0)

stripped of the dukedom and imprisoned in the tower to await an execution. He was saved only when Henry died; Mary Tudor restored his title.

The duke commissioned a chancel for Framlingham Church, which would serve as both a mausoleum for the family but also express their wealth and importance. One tomb contains the Duke of Richmond and Somerset, Henry VIII's illegitimate son who had died at seventeen. Old Testament scenes decorate the sides of his tomb. His wife Mary, daughter of the duke, was later laid to rest with him.

There is also the tomb of Mary Fitzalan and Margaret Audley – two of the three wives of the 4th Duke. The wives' own noble status is shown by their effigies in robes of state.

The third, comparatively plain tomb, is that of Elizabeth, the infant daughter of the duke and Margaret Audley. The most spectacular, brightly coloured tomb holds Henry Howard, Earl of Surrey (the 3rd Duke's eldest son), and his wife, Elizabeth Stafford. He, too, was executed for treason in 1547. At the foot of the tomb kneel his two sons, and at his head are his three daughters, glorified in their robes.

South of the chancel are the tombs of the 3rd Duke and Sir Robert Hitcham. Norfolk's tomb, which is of both English and French designs, carries the figures of Aaron, St Paul, and the twelve disciples.

Hitcham got himself in the chancel by virtue of buying the castle in 1635 and died a year later. A great benefactor to the village, his tomb is a black marble slab supported at each corner by a kneeling angel. His work for the poor is commemorated by the inscription.

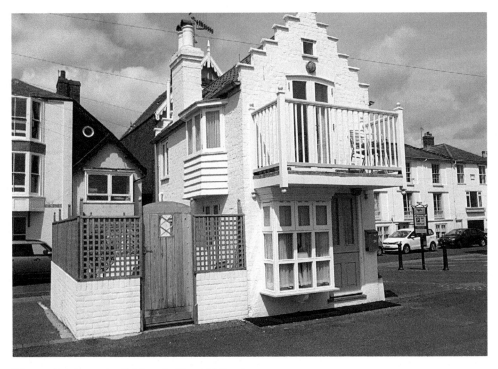

The smallest house in Aldeburgh. (Terry Philpot)

DID YOU KNOW?

The Check House in Framlingham is 7 feet wide with a floor space of 308 square feet, which makes it the smallest house in the county. It also has an eccentric layout, with a bedroom and shower room downstairs and the tiny combined living and dining area above.

The smallest house in Aldeburgh, appropriately named The Small House, stands on the front in Crag Path, in the middle of a car park. It is the width of a parking space, has a tiny-walled garden, and is very recognisable as Aldeburgh architecture.

A Unique Tower

Martello towers – small coastal forts – are not unusual and can be found from the United States to Sierra Leone. The first was built as part of Genoa's defences in the mid-sixteenth century. It was Captain William Ford who suggested that the British government copy that in Corsica, which he had seen the Royal Navy bombard unsuccessfully in 1794. They were also built in all four countries of the United Kingdom and in the Channel Islands. There were 103 Martell towers constructed in England from Seaford in Sussex to Aldeburgh, together with those in Jersey and Ireland, as a defence against the possibility of a Napoleonic invasion.

The tower in Aldeburgh (*see* page 19) stands at the isthmus leading to Orford Ness, and is the most north-easterly. It is unique in that it is quatrefoil – that is, it has

DID YOU KNOW?

Every year thousands pass the statue of Snooks, the friendly dog mounted on the column by the miniature yacht pond near the Moot Hall in Aldeburgh. The first statue of Snooks was erected in 1961 on the plinth to honour his owner Dr Robin Acheson, a local GP from 1931 to 1959. The name of his wife, Dr Nora Acheson, who carried on the practice after his death, was added when she died in 1981.

Snooks, whose name came from the fact that the family used to eat tinned snook (a fish), would follow his master on his rounds. He was known to eat pebbles, which necessitated operations.

The statue, though, is not the original, which had been stolen in February 2003. Local fundraising ensured a replacement was made from the same moulds. John O'Connor, an antiques dealer from Hawkedon, near Bury St Edmunds, bought the original at a fair in Lincoln. His later investigation showed him in 2012 that his was in fact the original and not a duplicate, and he returned it to Aldeburgh Town Council.

The original Snooks is on permanent loan in the grounds of Aldeburgh Hospital.

'four leaves' – and the tower has a decorative framework that is symmetrically shaped, forming an overall outline of four partly overlapping circles of the same diameter. This tower is the largest of the towers built between 1808 and 1812. It is owned by the Landmark Trust and is rented as holiday apartments. Together with the shingle bank and sea wall it is all that remains of what was the fishing village of Slaughden, which, by the early twentieth century had succumbed to the sea, although there are now two yacht clubs.

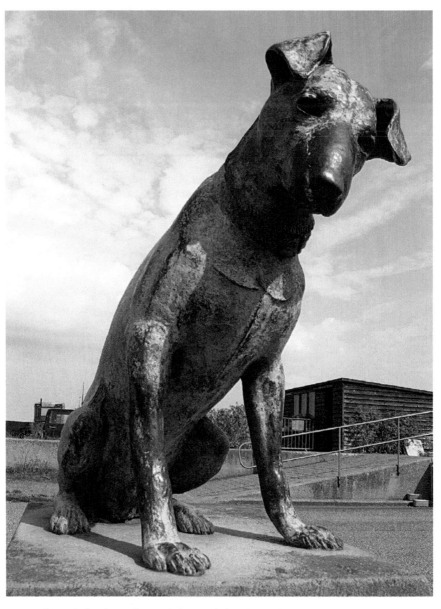

The statue of Snooks by the yacht pond. (Terry Philpot)

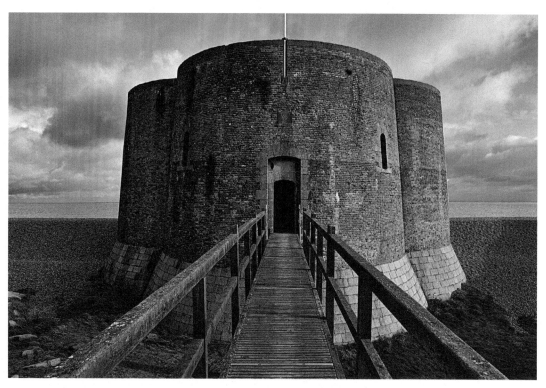

The Martello Tower, Slaughden. (Courtesy of D. Kirkham, Landmark Trust)

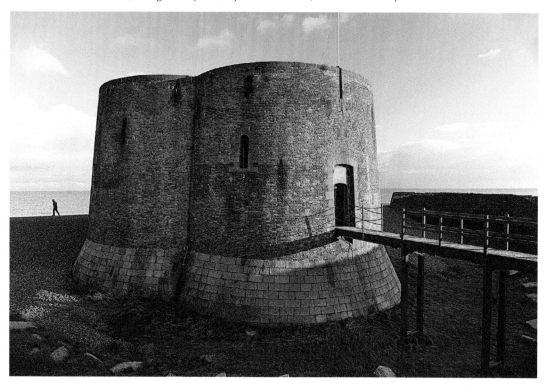

The Smugglers' Grave

Of all the tragedies and stories that a churchyard holds, few are as poignant or interesting as that testified by the grave in St Michael's Church, Tunstall, that is shared by William Cooper and Robert Debney, who died in 1778.

Robert Debney was thirty years of age when he died (although the tombstone lists him as twenty-eight). Baptised in the church, he was the son of Thomas, the farmer of Plunkett's Farm on Blaxhall Road. His friend William Cooper was eighteen and believed to have been the son of the local miller.

The two were smugglers and had constructed an underground vault for storing contraband gin, the entrance to which was hidden beneath a pile of horse manure. But on entering the vault, it is said that they died when overcome by the fumes. Their epitaph, reads:

> All you, dear Friends that look upon this Stone,
> Oh! think how quickly both their Lives were gone.
> Neither age, nor Sickness brought them to Clay;
> Death quickly took their Strength and Sense away.
> Both in the Prime of Life they lost their breath,
> And in a Sudden were cast down by Death.
> A cruel Death that could no longer spare
> A loving Husband nor a Child most dear.
> The loss is Great to those they left behind,
> But they thro' Christ, 'tis hoped, True Joys will find.

DID YOU KNOW?

Peasenhall has a village hall built in the style of a Swiss chalet because James Josiah Smyth, the designer and manufacturer of the seed drill, was so enamoured by a visit to Switzerland that when he returned he had the hall built to serve as a reading room for company employees.

The 'Swiss chalet' that is Peasenhall Village Hall. (Courtesy of Adrian Cable under Creative Commons 2.0)

The Sailors' Reading Room, Southwold

Reading rooms were common in villages and towns in the days before public libraries so that the poor should have access to newspapers and books. For those who could not read, there were sometimes others – often women – to read for them. One purpose, other than enlightenment, in creating the Southwold Sailors' Reading Room was to distract sailors and fishermen from local public houses and encourage them in Christian ideals.

But this Grade II-listed building is unusual in that it still serves its original purpose. Built in 1864, it is light with high ceilings – a place to be to enjoy reading and socialising.

A china bust of the blue-uniformed and besashed Captain Charles Rayley RN looks down from a wall, together with other paintings, photographs, barometers and model boats (some of which are in glass cabinets). It was in the captain's memory that the place was built. Charles joined the Navy when young and had an adventurous life. Fighting privateers in the West Indies, he received a sabre slash across the cheek and a consequent award of £80 from a newspaper.

In addition to the books and newspapers on large wooden tables, visitors can bring their own books to read from 9 a.m. to dusk (as the noticeboard quaintly puts it) in comfortable chairs in this homely place, or they can opt for a game of snooker in the back room.

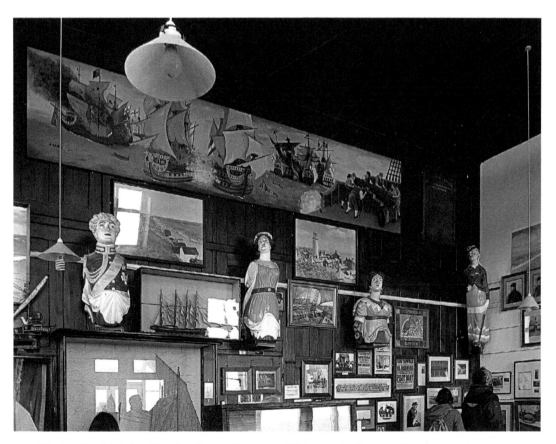

The Southwold Sailors' Reading Room. (Courtesy of Velvet under Creative Commons 3.0)

DID YOU KNOW?

In 1903 a Scottish barrister and landowner Glencairn Stuart Ogilvie (a friend of J. M. Barrie) inherited his family's estates, which included the then small fishing village of Thorpeness. He lived at Sizewell Hall, which is now a Christian conference centre. Influenced by the garden city movement in 1911 (when Barrie's novel *Peter Pan*, based on his play of the same name, was published), Ogilvie began the building of the holiday village that took its name from the fishing hamlet. Ornamental gardens, mock Tudor and Jacobean houses, a windmill, the House in the Clouds (in fact a water tower) and the 64-acre Meare – a lake – came to mark this extraordinary spot.

Ogilvie was so taken with his friend's play that he saw his creation as a Neverland, giving the Meare a Crocodile Island and The Fort. He named the small islands and creeks after Barrie's characters, and named a path Barrie's Walk.

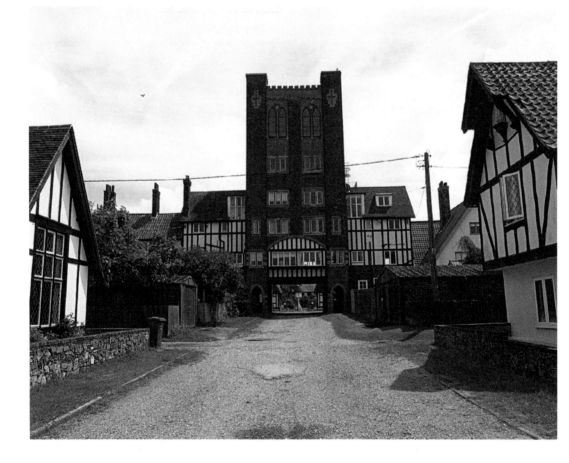

The Westgate, Thorpeness. (Terry Philpot)

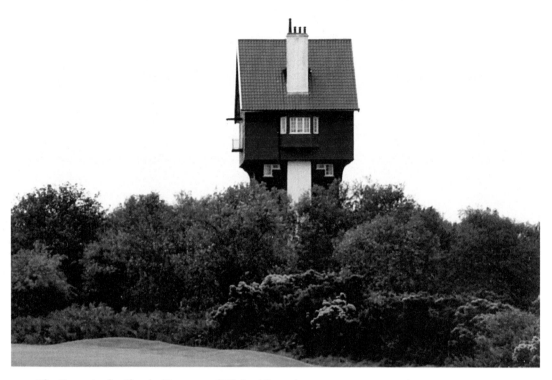

The House in the Clouds. (Courtesy of Michael Rouse)

3. The Garretts: A Remarkable Family

Richard Garrett founded the family engineering business in 1778; he died in the town in 1839. Three years later Richards oversaw and expanded the business in Leiston.

The third Richard Garrett was the brother of Newson Garrett, who was born in 1812 in Leiston and managed his father-in-law's pawnbroker shops in London. In 1838 he returned to Suffolk with his wife, Louisa Dunnell, and family in a 200-tonne hoy. Three years later he purchased a Snape corn and coal merchant's business and shipping interests, and the family moved to the Uplands, Victoria Road. In 1852 he built Alde House, Alde House Drive, in 35 acres, complete with an icehouse and Turkish bath. In 1854 he designed and built the malthouses at Snape, where he lived during the winter malting period. Over time, his business interests expanded to include shipping and a brewery in London.

Newson was a combative type whose altercations with the rector, which saw his periodic retreats to the Congregational Union Chapel, gave scandal and delight to his neighbours. When he converted to Liberalism from Conservatism, he fell out with Richard, and although their wives were sisters it is said that the men did not speak for thirty years.

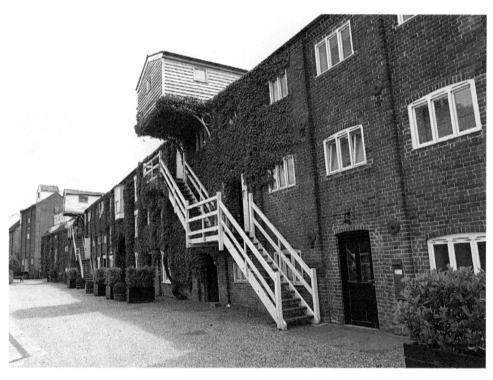

Above and opposite below: The present Snape Maltings buildings plainly show their original industrial use. (Terry Philpot)

Below: The Uplands, the Garretts' first Aldeburgh home. (Terry Philpot)

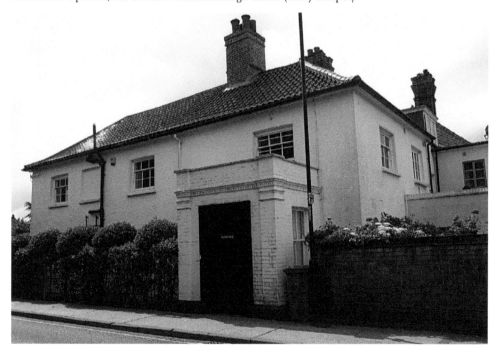

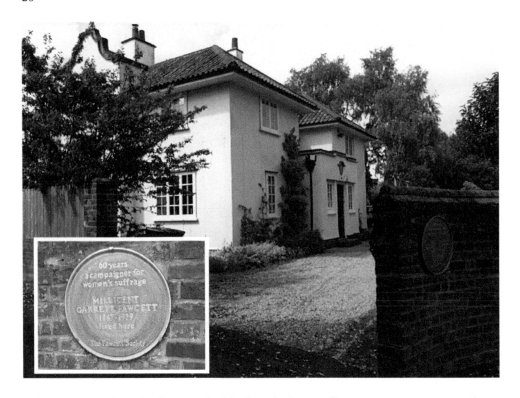

Alde House, which Richard Garrett had built and where Millicent Garrett Fawcett was born. Elizabeth Garrett Anderson moved here in later Life. (Terry Philpot)

He served on Aldeburgh Corporation and was a bailiff (a local official) for forty years. He was three times elected the town's mayor and served as an alderman, as well as a magistrate and Aldeburgh's first county councillor; he held various honorary positions.

The Garretts had nine children (four of whom survived infancy). They tended not to take to their mother's sabbatarian, pietistic evangelicalism (although her attachment to home and family influenced Millicent), but responded more to their father's encouragement of physical activity, reading, speaking their minds and sharing his political interests.

Apart from the social and professional obstacles in realising her ambitions, when Elizabeth, who was born in London in 1836, told her parents that she wanted to become a doctor, her mother exclaimed: 'Oh, the disgrace', while her father said, 'The whole idea is so disgusting I could not entertain it for a moment.' But Elizabeth persisted, and became the Britain's first qualified female doctor.

Elizabeth married Skelton Anderson, a wealthy businessman who built Aldeburgh's Jubilee Hall to mark Queen Victoria's sixty years on the throne and also created the town's golf course. Two of their three children included Robert, a public servant and ship owner, and Louisa, a suffragette and surgeon.

Millicent, the eighth Garrett child, was born in Alde House in 1847. She remembered seventeen ships being wrecked on the shoal of Aldeburgh with great loss of life. It had been cockney, she said, to refer to Crag Path as 'The Esplanade' or 'The Parade'. She became

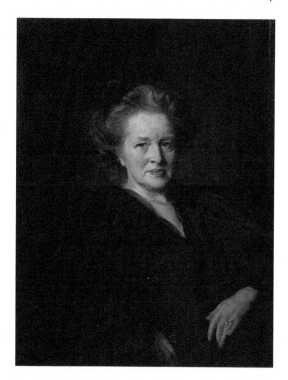

Elizabeth Garrett Anderson, a portrait by
Reginald Grenville Eves (1900).

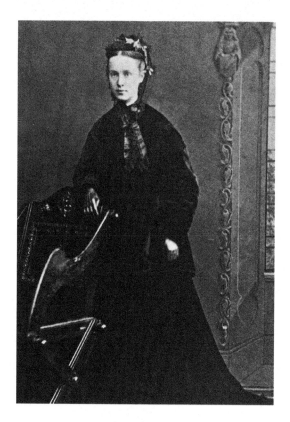

Millicent Garrett Fawcett in 1890.
(Courtesy of LSE Library, Flickr)

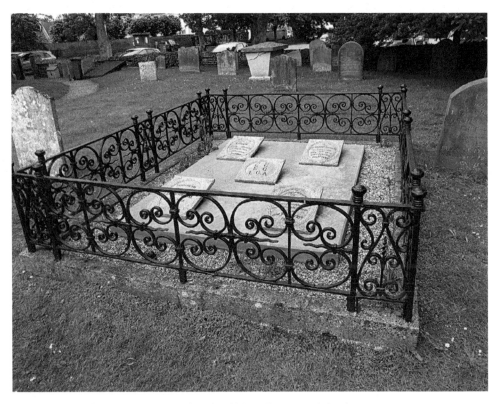

The Garrett family grave, St Peter's Church, Aldeburgh. (Terry Philpot)

leader of the constitutional suffragist movement and the founder of Newnham College, Cambridge. She married the blind Henry Fawcett, a Cambridge professor, Liberal MP and cabinet minister. Their daughter was Philippa, a mathematician and civil servant.

Elizabeth and Millicent's sister, Agnes, was a pioneering interior designer and suffragist, who went into partnership with her cousin Rhoda Garrett. Their work in spreading new and artistic ideas of domestic taste was considered as influential as that of Morris & Co. (Rhoda's half-brother, Fydell Edmund Garrett, was an associate of Cecil Rhodes.)

Millicent shared a house in London's Gower Street with Rhoda and Agnes, where she died in 1929.

Another cousin was Denis Garrett, botanist and professor of botany at Cambridge. His wife Jane's uncle, Martin Shaw, designed the sets for Britten's *God's Grandeur* for the first Malting Festival (*see* Chapter 5); and her sister was the painter Julia Perkins, who lived at Brudenall House, Aldeburgh (*see* Chapter 6).

Elizabeth retired to Alde House in 1902, where she had previously lived from 1841 to 1854. She was elected the town's first female mayor in 1908 and died at Alde House in 1917.

4. Living by the Pen

George Crabbe

Suffolk-born writer Ronald Blythe (*see* Chapter 5) wrote of Crabbe: 'There are poets who have made places, and places that have made poets. Where Crabbe and Aldeburgh are concerned the honours may be said to be evenly divided.'

Crabbe is best known for his poems 'The Village' and 'The Borough', which depict the realities of a harsh rural life far removed from contemporary romantic poetic idylls. 'The Borough', published in 1810 as twenty-four letters written in heroic couplets, portrays Aldeburgh as a wretched place. The poem used Suffolk people and places: Aldeburgh, Beccles, Woodbridge and Ipswich; the church, vicar, curate, the poor, prisons, religious sects, elections, professions, trades, amusements, inns, charitable institutions; and the workhouse, which it condemns. Crabbe's characters' psychological realism and his vivid depictions of their lives gave him renown.

Crabbe was born in 1754, the oldest of six children, on the south side of the town near Slaughden Quay in a house later lost in a storm. His father, also George, had been a schoolmaster and parish clerk in Norfolk before moving to the Suffolk village to become a collector of salt duties. The custom house was situated near the Crabbe home, and the son assisted his father in his fishing boat and sailing boat. Much of Crabbe's education came from his father, especially his love of mathematics, but Crabbe also loved reading – especially poetry.

At the age of ten, Crabbe was sent to grammar schools in Bungay and Stowmarket. He left at fourteen to be apprenticed to a farmer who was also an apothecary in Wickhambrook, although he worked more as a farmhand than as an apprentice apothecary. Back in Aldeburgh, he worked in his father's warehouse and then as an apprentice to a surgeon in Woodbridge, where he learned anatomy by dissecting dogs. While there he began to publish poetry and won a prize from a magazine.

In Aldeburgh, Crabbe took over a local apothecary's. A year later he went to London to improve his medical knowledge, placing his practice with a local surgeon. Crabbe's practice was largely among the poor and so he fell into debt. In 1780, at twenty-six, he described himself as 'starving as an apothecary in a venal little borough in Aldeburgh Suffolk'.

In London his hopes of a literary life eluded him, but under the patronage of the statesman Edmund Burke he discharged his debts, and lived with the Burkes in their home in Beaconsfield. Following Burke's advice, he secured a curacy in St Peter and St Paul's Church, Aldeburgh. He preached his first sermon in January 1782, saying of it: 'I had been unkindly received in the place—I saw unfriendly countenances about me, and, I am sorry to say, I had too much indignation,—though mingled, I hope, with better feelings,—to care what they thought of me or my sermon.' His surly parishioners resented his social

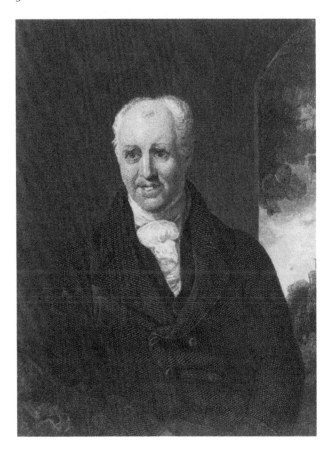

George Crabbe. (Courtesy of
the Welcome Foundation under
Creative Commons 4.0)

class and success when he had so recently failed as an apothecary. Their attitudes may
have been shaped by the fact that when tithes were due, he would climb the pulpit and
proclaim, 'I must have some money, gentlemen.' He always read his sermons and repeated
them at different times and in different churches. Common humanity and decency were
often the themes. Then, also in 1782, Burke helped him to become chaplain to the Duke of
Rutland in Leicestershire.

Crabbe published 'The Village' in 1783 and continued with his poetry and other
literary work, including novels. He completed a treatise on botany, which he burnt when
the vice-master of Trinity College, Cambridge, told him that English was not a suitable
language for a scientific work.

A Cambridge LLB degree, gained after a two-hour examination in Latin, gave him
two livings in Dorset, worth £200 a year. On this basis he was able to marry Sarah Elmy,
daughter of a Suffolk bankrupt who had deserted his family. She is often mentioned in
his poems as 'Mira' – the name he called her.

In Leicestershire, where he had a curacy for four years at Muston, he and his wife had
four children, two of whom died in infancy, just hours after birth. Two other sons were
born later. After the deaths of Sarah's uncle and her older sister, she inherited the estate
at Parham near Aldeburgh, and so in late 1792 the Crabbes moved back to Suffolk, free

of financial worries. It was there that he developed a habit that continued for the rest of his life: he took opium first for attacks of vertigo and then to suppress painful attacks of facial neuralgia. But Crabbe was still the (absent) rector of his Muston parishes, causing many parishioners to leave for dissenting congregations.

In Suffolk, Crabbe became the curate in the neighbouring living of Sweffling in 1794. In 1797 he also took on the curacy of Great Glenham and became a frequenter of Little Glenham Hall, which Crabbe rented at one time as a retreat for Sarah, who suffered from manic depression – possibly brought on by the death of her children. In 1801, when Glenham estate was sold, the Crabbes had moved to nearby Rendham. That year he was directed by the Bishop of Lincoln to return to his Muston parishes, something he avoided for four years. Sarah died in 1813.

Crabbe would go to London for the season, mixing with many notables of the day like John Murray, who became Crabbe's publisher and paid him £3,000 for all his copyrights. In 1822 he visited Sir Walter Scott in Edinburgh.

The duke arranged that Crabbe's Muston living be exchanged for one in Trowbridge, where he was rector from 1814 to 1832 and became a town magistrate in 1826. He broke off an engagement to a younger woman named Charlotte Ridout, likely due to the objections of his sons (both of whom were clergymen), but he also knew he could not support a young family. He died from fever at the rectory in 1832.

Wilkie Collins

In 1862, four years before he published *The Moonstone*, the first English detective or suspense novel, Wilkie Collins set one of his lesser-known novels – *No Name* – partly in Aldeburgh, or Aldeborough as he called it. It is precise in its sense of place, although he only stayed in the town itself for probably no more than a few days; indeed, little is known about that stay, other than it was likely toward the end of August the year before publication. The year before that, he had found lasting fame with the bestselling *The Woman in White*.

Convalescing after pain caused by a liver complaint, and contemplating a new novel in Broadstairs, he wrote to his mother that he was unable to decide where to travel to seek a venue – it might be Scarborough, it might be Lowestoft. As it was, he travelled to Whitby and then York. He probably then settled on Aldeburgh. What Collins did and where he stayed in Aldeburgh is not definitely known. His two most recent biographers, Peter Ackroyd and Andrew Wycett, do not even mention his stay or that the novel is set partly in the town.

The belief is that he arrived by train that summer – a four-hour journey from London – because in 1859, when the novel is set, the line stopped at Ipswich. The White Lion was the best and oldest of the town's hotels, so it is possible a successful author might have stayed there. Collins must have familiarised himself with the town and its places. Perhaps North House, near the hotel, is Collins' North Shingles, where the novel's protagonist Magdalen Vanstone is staying, having stayed also at Sea View Cottage. She arrives here via West Somerset, York and London.

The novel refers to Aldeburgh as 'a last morsel of land which is firm enough to be built upon', where its inhabitants have settled after the advance the sea: 'a strip of ground

Left: A cabinet card image of Wilkie Collins, *c.* 1889.

Below: The White Lion Hotel, Aldeburgh's oldest, where Wilkie Collins probably Stayed. (Terry Philpot)

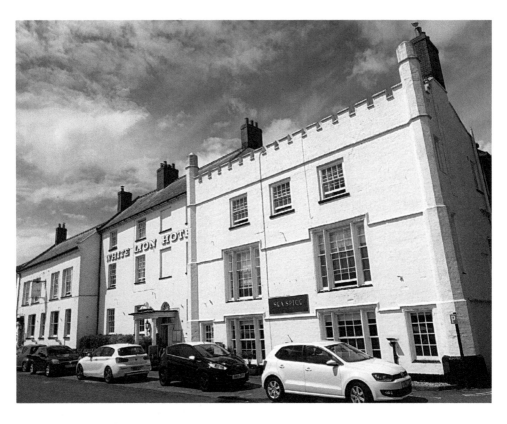

hemmed in between a marsh on the one side and the sea on the other ... a quaint little watering place.' There are 'fanciful little houses, standing mostly in their own gardens'. The novel especially remarks on the Moot Hall as 'the tiny Gothic town-hall ... once the centre of the vanished port and borough – [that] now stands, fronting the modern villas close on the margin of the sea'.

The author also refers to 'a wooden tower of observation', presumably the precursor of the now-brick Lookout Tower on Crag Path. Behind it is 'a straggling street, with sturdy pilots' cottages, its mouldering marine store houses, and its composite shops. At the northern end of this street, we are told, is 'a low woody hill' on which St Peter and St Paul's Church is built, 'one eminence visible over the marshy flat'. Reference is made to 'the forlorn outlying suburb of Slaughden'.

Crag Path becomes The Parade (as it was sometimes called informally) in the novel, a place where, says Captain Wragg (Magdalen's distant relative and a fraudster), a walk will cause everyone to meet. It is at the 'deserted Martello Tower' that Magdalen tells Wragg how she proposes to get back her fortune, which she and her sister Norah have lost to their estranged uncle upon the discovery that their parents had married only a few months before their deaths – he in a train crash, she in childbirth – thus making their daughters illegitimate and ineligible to inherit. She intends to marry her uncle's son, Noel, who does not know her and whom she does not love.

At the villa Magdalen contemplates suicide at the thought of marrying a man she does not love, but she chooses life – or rather fate does, as her decision rests on calculating how many ships will pass her house within half an hour. She marries Noel in the local church and then the novel's action moves from Aldeburgh to Dumfries and London again, then back to Dumfries.

Margery Sharp

There is now a plaque on the pretty house halfway up Crag Path, but that is all most people will know of Margery Sharp. Yet she wrote twenty-six novels for adults, fourteen for children, two plays, two mysteries and numerous short stories. Her best-known book is *The Rescuers*, later adapted by Walt Disney into two animated films, *The Rescuers* and *The Rescuers Down Under*.

She was born in 1905 in Wiltshire, lived in Malta for a while as a child, studied art, and established herself in British and American journalism. In 1940, two years after her marriage to an aeronautical engineer Major Geoffrey Castle, her seventh novel *The Nutmeg Tree* became a Broadway play called *The Lady in Waiting* and seven years later became a film, *Julia Misbehaves*, starring Walter Pigeon and Greer Garson.

She and her husband lived in The Albany, Piccadilly, London, but she was well established as a writer when they moved to No. 32 Crag Path. Margery moved from the house in 1990 but died in Aldeburgh the following year.

Ronald Blythe (*see* Chapter 5) remembered Sharp from afar many years later. He was in Aldeburgh to open the Suffolk Group artists' exhibition, and he tells us:

> I vanish for a few minutes to see once again a particular house along the Crag Path, which
> held for me a fascination when I lived in Aldeburgh. It was the home of the novelist

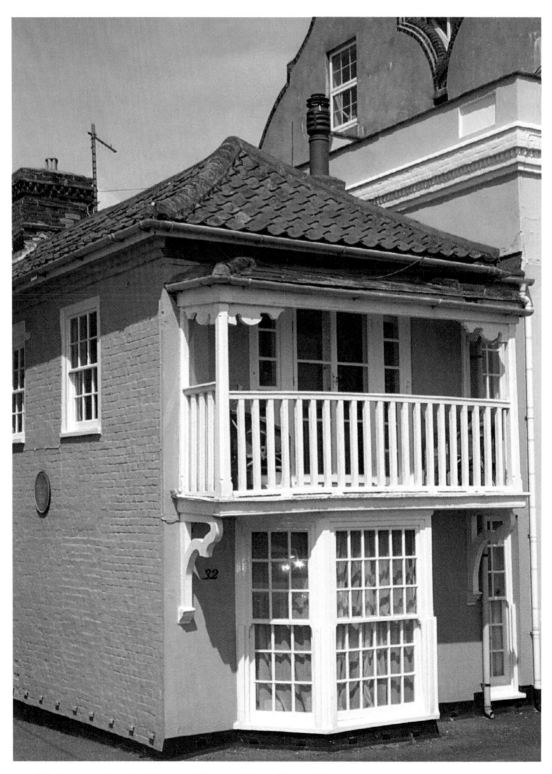

The house on Crag Path, home of Margery Sharp. (Terry Philpot)

Margery Sharp ... and I regarded it, not without amusement, as an idyll purchased out of fiction. I would glance up at its little balcony late of an evening, and there she would be, elegant with her husband Major Castle and a glass of wine beside her, playing chess to the roar of the North Sea, framed in the lamplight, secure in her publishers. This evening the balcony the balcony was deserted and the folding doors behind it closed. But the tall thin house remained utterly desirable.

George Orwell

It was George Orwell's sister, Avril, who said that her brother 'loathed' Southwold. But did he? True, it was never his permanent home, but he had few of those in his wandering, adventurous life. He did, however, stay here for long periods with his parents at their handsome double-fronted red-brick house at No. 36 High Street.

Indeed, if he hated it so much, why take the name of the Suffolk river – Orwell – as his last name, inescapably associating himself with that part of the world? His original name had been Eric Arthur Blair. He disliked Eric and dropped it in favour of his pseudonym, along with Blair, for his first book in 1933, *Down and Out in Paris and London* (written in Southwold), so as not to embarrass his parents and to guard against failure. George may have been chosen because his father, Richard, adopted it for all casual male acquaintances, or it may have been because of his admiration for George Gissing, who also had the same surname as a Norfolk village not 30 miles east of Southwold. (Orwell may have been struck by the coincidence of names when passing through the Cambridgeshire village of Orwell.)

Orwell was born in India, where his father, Richard Blair, was sub-deputy opium agent in Bengal. Educated at Eton, he lacked attention to his studies. He didn't go to university but entered the Imperial Police, forerunner to the Indian Police Service, to work in Burma (then part of India). To prepare for this he spent January 1922 to June that year at a crammer's, called Craighurst, in Southwold. When he quit the police service, his parents became alienated from him for giving up what they saw as a secure government job. He took himself off to Paris for two years.

In 1921 his father retired and his parents moved to No. 40 Stradbroke Road, Southwold, and later to No. 3 Queen Street. When his father was seventy, and still disappointed with his son, Orwell came to Southwold, picked up old friendships and got a job looking after an 'imbecile boy' in Walberswick. He liked children but found the job frustrating so much, so that he makes reference to the problems of dealing with such a child in *A Clergyman's Daughter*, in which he evokes Southwold as Kynpe Hill. He also wrote *Burmese Days* in Southwold.

Visiting Walberswick churchyard, Orwell claimed he saw a spectre – there were ghost stories about the village – and had other uncanny experiences about which he wrote to friends.

In Southwold he also did some journalism, and was often seen – a scruffy figure in ill-fitting clothes – fishing from the pier or standing awkwardly on the sidelines at local dances. He walked the family dog Hector, swam in sea, and painted, using a beach hut owned by friends. His sister Avril owned the Copper Kettle Teashop in Queen Street.

Left: George Orwell.

Below: The home of George Orwell's parents in Southwold, where the author frequently stayed. (Terry Philpot)

Impecunious he may have been but he pursued three women simultaneously: Brenda Salkeld, a teacher at St Felix School for Girls, who rejected his offer of marriage (she was also a clergyman's daughter); Eleanor Jacques, 'the girl next door'; and Ruth Pitter, the poet, a friend of his parents and his senior by six years. Pitter was to take an (often critical) interest in his writing.

In June 1932, he wrote to Salkeld: 'I think it would perhaps be best for me to go to some quiet place in France, where I can live cheaply and have less temptation from the World, the Flesh and the Devil than at Southwold (You can decide which of these categories you belong to.)' A few months later he wrote again recalling 'the day in the wood' which may have inspired the woodland love scenes in *Keep the Aspidistra Flying* and *1984.*

Though he spent some time in his later years in Southwold (he was there when his father died in 1939), he was often coming and going. When one of these outings resulted in him getting caught in a downpour and suffering from a chill that developed into pneumonia, Orwell looked to return straight to his family home in Southwold – just as soon as he was discharged from hospital.

After sending off *A Clergyman's Daughter* to publishers, he moved back to London to take a job as a part-time assistant in a second-hand bookshop in Hampstead. He had some success with future novels – though nothing to rival *Animal Farm* and *1984* – at the end of his life, gained a foothold in journalism, fought in the Spanish Civil War, married Eileen O'Shaughnessy (his first wife, who died in 1945), served in the Home Guard, and worked for the BBC during the Second World War. He married his second wife Sonia Brownell in 1949, three months before he died at the age of forty-six on the island of Jura.

Whatever were Orwell's thoughts about the town, where he spent so much time, it inspired aspects of his early work and saw him emerge as an author; today a plaque on the High Street house recognises that important connection.

Patricia Highsmith

Patricia Highsmith, creator of the six Ripley novels, is perhaps an unlikely inhabitant of this part of Suffolk. Born in Texas in 1921, Highsmith set her novels in places as varied as Greece, Crete, Morocco, Italy and France. She died in 1995 in Switzerland, where she had lived for fifteen years.

In 1963 Highsmith was living in Positano on the Italian coast and was writing the tenth of her twenty-two novels, *The Glass Cell*. She had planned a holiday in Suffolk with her long-distance lover from London, a married woman called 'X' by biographer Andrew Wilson and 'Caroline Besterman' by the later biographer Joan Schenkar. They went to Aldeburgh, which Highsmith described as 'full of the atmosphere and domestic décor which I shall call 1910 or Edwardian', and noted that a haircut cost 2s 6d (13p) and a small lobster 5s 6d (28p).

She returned alone to Positano and then took an apartment in Rome where she finished *The Glass Cell*, although her publisher then demanded substantial changes. Depressed, worrying about money and regretting the move to Rome, she went to London briefly in November and then moved to No. 27 King Street in Aldeburgh at a rent of 5 guineas (£5 5s or £5.50) a week. It was here that she heard of the assassination of President Kennedy. Richard Ingham, an aspiring writer and then a mathematics teacher at Woodbridge

Patricia Highsmith, an unlikely Suffolk resident. (Courtesy of Open Media Ltd under Creative Commons 3.0)

School, lived in Aldeburgh at the time and remembered Highsmith 'bursting into our flat ... and absolutely bellowed: "Oh, Richard, what the hell's wrong with America?"'

In April 1964 she bought Bridge Cottage in Earl Soham, a few miles from Aldeburgh – 'so picturesque', she told one friend, 'as to be unbelievable'. It was, she told the author Arthur Koestler, 'a good place for writing, due to the extreme English quietude' and because her lover was in London most of the time.

Living nearby in Debach was the author Ronald Blythe (*see* Chapter 5), who became a frequent visitor. Sometimes she would stay at his house if she'd had too much to drink. Blythe remembered Bridge Cottage as 'clean and comfortable, orderly and warm', but that Highsmith always wanted to get back to writing, which 'made her happy, gave her something that nothing else could'. While they enjoyed a friendship and he found her warm, he also said, 'I don't think she was connected to what people call "the real world". She was cut off from what we think of as ordinary life, cut off by her genius.' Blythe and Highsmith were never lovers, though they did sleep together a few times.

She wrote *A Suspension of Mercy* in Bridge Cottage, which opens with a description of the Suffolk countryside. Her protagonist, Simon Bartleby, an American television scriptwriter, lives in Roncy Noll, the renamed Earl Soham.

Highsmith famously preferred animals to people (particularly cats) and in the large garden at Bridge Cottage she bred 300 snails. She became so fond of them that she even

travelled with some in a large handbag. In January 1966 *Nova* published a short story by Highsmith called 'The Snail Watcher', which Graham Greene commended for 'its sheer physical horror'. She also wrote another snail horror story around this time called 'The Quest for Blank Claveringi'. While at Earl Soham she also wrote *Those Who Walk Away* between October 1985 and March 1966.

During her Suffolk years, Highsmith travelled extensively, often in Europe. In 1967, her often unhappy four-year relationship with 'X' ended and she moved to the countryside near Paris.

Laurens van der Post

For many years, almost until his death, Laurens van der Post – traveller, writer, soldier and alleged mystic – was a well-known figure in Aldeburgh. His second wife, Ingaret Giffard, a would-be writer and actress, had found Aldeburgh in the 1930s – this was before she had met van der Post and before they divorced their respective spouses. After their marriage in 1949 they lived first in her small home, the late eighteenth-century Grade II-listed Half Crown Cottage on King Street. He was to enjoy the town as a summer retreat for more than three decades.

He later sold the cottage to his son John and his family, and van der Post and Ingaret bought Turnstones, a house with both a sea view and garden, which their former home had lacked.

He also rented the middle floor of the Lookout Tower (the distinct building on Crag Path that overlooks the sea) from Geoffrey Castle and his wife, the novelist Margery Sharpe (see above) for £1 and one flamingo feather a year. He also owned the tower later for a while. It was here that he worked, dictating to his assistant.

Born in 1906 in what is now South Africa, his first novel, *In a Province*, appeared in 1934. His second book *Venture into the Interior* (1952) was written during his Aldeburgh years, as were many others later. His fame as a broadcaster and author had increased over the years. He was an honorary Englishman, his place in the centre of the Establishment confirmed by the knighthood he received in 1981 and his friendship with Prince Charles, which led to him becoming a godparent to Prince William. He was much sought after for social events and he undertook speaking and publicity engagements.

He valued Aldeburgh for its distance and quiet. It was a place he could work, but also where he could relax playing tennis with the composer Benjamin Britten, the singer Peter Pears and the humorist Stephen Potter and his wife Mary, a painter. This Aldeburgh group included visitors like the comedian Joyce Grenfell, the novelists Rosamund Lehmann and William Plomer, and the art historian Kenneth Clarke (*see* Chapters 5 and 9).

Popular in the town and with his friends, and greatly admired worldwide – revered even by some – van der Post was not wholly the person he presented to the world. Indeed, his last book, an autobiography titled *On Being Someone Other*, ironically summed up the other Laurens van der Post.

His authorised biographer J. K. F. Jones wrote:

A curious feature ... is that Laurens consistently preferred to keep [his two lives] separate ... and many people who knew him only in one of two of these 'boxes'. It was possible

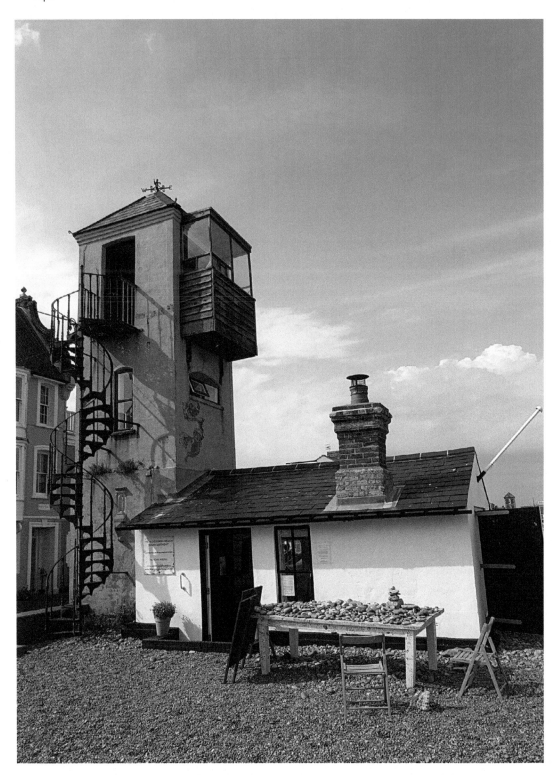

The Lookout Tower on Crag Path, where Laurens van der Post worked. (Terry Philpot)

to be a good friend of his in Aldeburgh and have no idea of why or whether he had just been to Balmoral with Prince Charles, to Jung's house outside Zurich, to the Umfolozi game reserve, or to preach a sermon in New York.

But what was shocking was the fact that it would appear that van der Post, as Jones claims, often recounted Bushmen stories as if they were part of his experience – he failed to make a distinction between telling a story, which may or may not be true, and incorporating oneself in the story. That rather dented some of the fame that has accrued to the Bushmen books and the myths (in the correct sense) and philosophy that he had insinuated into them. When *Yet Being Someone Other* appeared in 1982 and before he had begun work on his biography, Jones called the purported autobiography 'fiction, or, better, a romance'.

But there was more. Jones revealed that this moral guardian of mankind, as some had come to see him, had fathered a child with a fourteen-year-old girl in 1952, to whom her parents had entrusted him on a voyage from South Africa to England. Van der Post never acknowledged the child.

This was not, though, some lapse. Before he had married Ingaret he had been engaged to a seventeen-year-old girl. In his sixties van der Post started a long affair with a much younger woman, who would travel to Saxmundham station and stay with him in Aldeburgh soon after Ingaret had left to visit her mother in Camberley. (They also spent time in his Chelsea apartment and travelled abroad, sleeping in a tent.) This was four years after meeting and becoming involved with another much younger woman. These were not the last of his extra marital relationships. There was one, when he was at seventy-eight, where, according to his authorised biographer, the young woman claimed she felt she had been raped.

But in his lifetime all that really touched van der Post negatively was his favouring Chief Buthelezi, the Zulu leader and leader of the Inkatha Party, against Nelson Mandela as leader of a would-be free South Africa. In this van der Post was said to have influenced Margaret Thatcher's judgments about South Africa and Mandela, whom she infamously referred to as a 'terrorist'.

That apart, van der Post enjoyed the esteem that had been his for more than fifty years in Aldeburgh as much as in many of the world's capitals. But as frailty increased, he and Ingaret sold Turnstones in 1992 and lived in their Chelsea apartment, coming back to the town only occasionally. He died in 1996; she six months later.

Penelope Fitzgerald

Fitzgerald's brief years in Southwold were not her happiest, but they proved to be highly productive because her experiences led her to write her small masterpiece, *The Bookshop*.

Fitzgerald was born in 1916 into a family that included clergy, bishops and writers – her father was Evoe Knox, one-time editor of *Punch,* and an uncle was Monsignor Ronald Knox, the Catholic writer. In 1942 she married Desmond Fitzgerald of the Irish Guards, with whom she had three children. They had very little money: his efforts at earning a living as a lawyer were unsuccessful and dogged by ill luck; her journalism and teaching barely enabled them to scrape by.

In 1957 they quickly left their Hampstead home in a chaotic state and took refuge in Southwold, probably because they were offered a house there, through friends, staying at Blackshore, next to the Anchor Inn near the ferry. It was a town reliant on fishing, farming, reed cutting, working in pubs, manning the lifeboat, tourism, and shopkeeping, and it was marked by class hierarchy. Their daughters Maria and Tina went to local schools, and their son Valpy went to a private school in Beccles and then to a boarding school at Westminster, from which he was later withdrawn when his parents could not meet the fees. There was a boat nearby for sailing and the girls rode ponies. Tina had a short novel published in 1960.

Fitzgerald took to country life, making cowslip wine and pickling apples. They also mixed with the Freuds (the future Sir Clement, broadcaster, writer, chef and Liberal MP, and his family) and the Fiennes (the parents of the actor Ralph) in Walberswick.

Desmond, who could rarely find a brief, lived with his mother in London during the week. He drank too much, and he and Fitzgerald rowed when he came home at weekends. She drove around Suffolk in a Ford Consul without a licence. They ran up bills and were denied credit.

The offer of a part-time job in the Sole Bay Bookshop, run by Phyllis Neame, who became a staunch friend, was welcome but not the financial answer. Fitzgerald claimed the shop was haunted, just as the bookshop is in her novel (the poltergeist is a major character).

In 1959, when the childless widow Florence Green opens her shop in *The Bookshop*, the Fitzgeralds' world fell apart: their possessions were put on the pavement outside their home by auctioneers to be sold and, after a spell in a hotel, she moved with the girls to a small house at No. 8 High Street. Their son Valpy went to Downside, where his fees were remitted.

The relationships with the town's upper classes fell away and Fitzgerald reflects in the novel how Florence faces the opposition of a conservative and parochial community. The book is socially and geographically precise in detail – the Hardborough of the novel and its surroundings are easily identifiable – and a comedy of the townspeople and customers, but it is also a dissection of class prejudice, snobbery and petty-mindedness. This Southwold and the selling of books in Suffolk in the 1950s – even stocking up on *Lolita*, as did both Neame and Florence – are very much Fitzgerald's experiences.

The ending is not a happy one – all that Florence fears comes about – and neither was it for Fitzgeralds. The family decamped from Southwold to live on a decrepit barge on the Thames. *The Bookshop*, her second novel, which was shortlisted for the Booker, was published in 1978. *Offshore*, drawing on her life on the Thames won the award the following year.

There were to be more novels and non-fiction, which still remain in print today, decades after they were first published.

R. J. Unstead

Robert John Unstead was born in Kent in 1915. He moved to Reedlands, a house that let onto The Meare in Thorpeness, with his wife Florence and three daughters – Judith, Susan and Mary. Unstead qualified in 1936 as a teacher and joined the RAF during the

Second World War. He took part the D-Day landings, and saw service also in Greece and Italy.

He became a head teacher in Letchworth in 1957 and turned to writing popular children's history books when, reviewing books for *The Times Educational Supplement*, he saw that what his pupils were offered was pretty standard fare, with a tendency to view history in terms of monarchs. He believed that they were more likely to be deterred than encouraged. His first book, *Looking at History*, came out in four volumes. In the *Middle Ages* volume he wrote, 'You will not find very much about kings, queens and battles in this book ... this is a book about everyday people and things.' In the fourth book, *England: A History* (1963), he explained that 'at a time when it is fashionable in some quarters to belittle England's achievements in the past and to doubt her place in the future, I have tried to show that whereas England has often acted foolishly or badly, her history shows the persistence of ideals which good men have lived by since Alfred's day'. The four books sold 8 million copies.

Unstead's books were very successful due to the ease of writing (he strove to simplify but never wrote down to his young readership), the varied subject matter, and the lavish and colourful illustrations. They proved popular not only with teachers and pupils but became the kind of books that children wanted to read in their own time. His gifts were obvious in his relations with children. He was modest and welcoming and when my own then small son and I visited him at home, it was the child, not his father, upon whom his attention was focussed and about whom he wanted to know.

His daughter Mary described their Thorpeness life in the 1960s as 'an endless party atmosphere and lots of entertainment to be had with social activities and many friends. Mum and Dad loved every minute; they played golf, bridge, tennis and enjoyed a very social scene'. The children had their own boat on the Meare, which Unstead's grandchildren were to later enjoy.

He visited Australia to provide advice on a series about the country's history based on the Unstead style. He also went to the United States after his *History of Great Britain* became the Library of Congress's Book of the Year. There the family lunched at the White House, where Paul Getty was also a guest.

Unstead also chaired the governors of Leiston Middle School from 1973 to 1985 and Coldfair Green Primary School. At the latter he funded annual history and achievement prizes.

He published more than a hundred books in total, including his ambitious and bestselling *A History of the World* in 1983, which covered the ancient world to the Second World War. When he died in 1988, he was working on a history of the 1940s in collaboration with his daughter Susan, herself a children's author. He is buried in the churchyard of St Andrew, Aldringham.

5. Benjamin Britten, Peter Pears and the Aldeburgh Festival Circle

That Benjamin Britten and Peter Pears were lovers long before homosexual acts were decriminalised in 1967 was widely known in artistic circles and among friends. Their relationship and celebrated musical collaboration – not least of which was the co-founding (with the librettist Eric Crozier) of the Aldeburgh Festival – have linked their names inextricably.

In August 1947 when they were on tour in Switzerland, Pears suggested that they create a local festival 'with a few concerts given by friends'. The original idea of a music festival widened to include poetry readings, literature, drama, lectures and art exhibitions. The first festival was held between 5 and 13 June 1948. The main venue was the Moot Hall in Aldeburgh, and some other venues were brought into artistic use, including Aldeburgh's parish church, the Baptist Chapel, the Jubilee Hall, the cinema, hotels and even the beach. In 1958 the festival stretched to Holy Trinity Church, Blythburgh and also Framlingham and Orford.

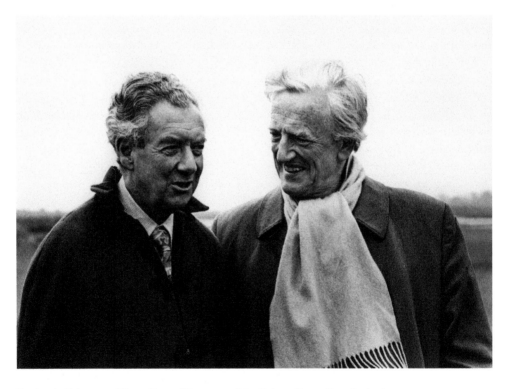

Benjamin Britten and Peter Pears. (Courtesy of the Britten-Pears Foundation)

Peter Pears as Sir Philip
Wingrave in Britten's *Owen
Wingrave*, 1971.

In 1937 Britten bought and converted a disused mill, granary and miller's cottage as a home in Snape for £450. The Old Mill was where he composed *Peter Grimes*. The Old Mill's balcony overlooked the malthouses, later to be converted into a concert hall that preserved much of the original architectural character. When Ronald Blythe watched the old industrial buildings at Snape being recreated as a concert hall, he wrote, 'I had seen the gradual emptying of almost a malt city.' It was opened by the Queen in 1967.

Britten and Pears gathered many people about them, in varying degrees of attachment, some of whom would only much later become well known in their own right. Joyce Grenfell was already much renowned as a comedian, monologist, and radio and film star when she first came to the festival in 1962. She returned every year until 1979, dying at the age of sixty-nine three weeks after her last visit. Her husband Reggie always accompanied her, combining their interests in music (of which she had a vast knowledge), birdwatching at Minsmere and meeting friends – both famous and obscure. She would often swim in the sea in front of the Wentworth Hotel, Aldeburgh, where the couple always stayed.

She told both Bitten and Pears she regarded it the 'highest accolade' of her life to be asked to perform her popular songs at the festival, and did so several times. Non-musical performers also joined her, such as the actors Sir John Gielgud and Dame Peggy Ashcroft, and the poet and writer William Plomer. Viola Tunnard, Grenfell's friend and accompanist, also performed at the festival.

In 1957 when the public became too intrusive for them at Crag House (No. 4 Crabbe Street), which Britten had bought in 1947, the two men swapped their home for the Red House. This belonged to Mary Potter but was now too big for her after her divorce from the humorist Stephen Potter, who had moved to London. While Stephen Potter had known Britten a little through the BBC before him and Mary moved to Aldeburgh, it was she who made real friends with Britten and Pears. It was never her intention to make Crag House a permanent home and, at the time of the exchange, discussed with Britten and

Right: Joyce Grenfell, a friend of Britten and Pears and frequent festivalgoer. (Courtesy of Alan Warren under Creative Commons 3.0)

Below: Crag House, Crabbe Street, where Benjamin Britten and Peter Pears lived before swapping it with Mary Potter for the Red House. (Terry Philpot)

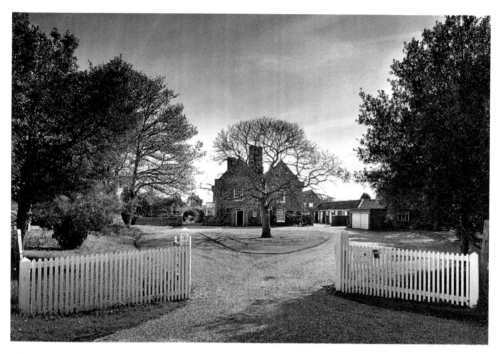

The Red House, last home of Benjamin Bitten and Peter Pears. (Courtesy of the Britten-Pears Foundation)

Pears about building a studio house in the Red House grounds. This was completed in 1963 and she lived there until her death in 1981. On one occasion Grenfell came back out of the concert season to have her portrait painted by Mary Potter in her studio home.

For all but one year (and that was when they came together) Grenfell wrote daily letters to her friend Virginia Graham, describing performances, birdwatching, who she'd met, conversations, incidents, and who and what she observed. At the end of each season she'd write to Britten describing that year's festival as the 'best ever'. Two years after the Maltings opened in 1967, and two nights before the festival, there was a disastrous fire and she wrote a consoling letter to Britten. It was reopened two years later.

Ronald Blythe was another who played a part in the festival. He knew Britten and Pears long before Grenfell and was an obscure and aspiring writer in those days. Blythe was born in Acton in mid-Suffolk (a common Suffolk heritage that united him with the Lowestoft-born Britten) and was later to achieve fame through his books *Akenfield* and *The View in Winter*.

Blythe came to Thorpeness in 1955 to rent Fairhaven, a Victorian bungalow, behind which was the cottage where Eric Crozier and his wife Nancy Evans, the mezzo-soprano, lived. Blythe was then writing short stories to earn money while working on his first novel *A Treasonable Growth*, which features a thinly disguised Aldeburgh.

One snowy day in Aldeburgh he passed the novelist E. M. Forster. Neither knew the other, but when Blythe returned to Fairhaven there was a note from Forster inviting him for a drink at No. 4 Crabbe Street, where he was staying. When he went, he

helped index Forster's life of his aunt, whose legacy has allowed him to write. He must then have met Britten and Pears but does not name them, referring only to them as 'they'.

Britten and Pears' connection with Forster came from reading a reprint of the latter's radio talk on the Aldeburgh vicar and poet George Crabbe in *The Listener* when they were in the United States in 1941 (they had become lovers in 1939). It resulted in Britten's opera *Peter Grimes*, although Forster opposed the licence taken with the text by Montagu Slater's libretto. Forster and Crozier wrote the libretto for *Billy Budd*.

Eager to boost his meagre income, Blythe undertook photo journalism assignments with Kurt Hutton (formerly Hubschmann), who was married to Gretl Ratschintsky and lived at No. 36 Crag Path.

Blythe collected friends as he collected anecdotes and reminiscences. He made frequent excursions to Wormingford over the border in Essex to see his friends, the artist John Nash and his wife Christine at their home Elizabethan home, Bottomgoms Farm. He later moved 17 miles away to Boulge, and inherited the Nashs' home, where he has lived since 1977.

Blythe was also friendly with the Cranbooks (Fidelity Gathorne-Hardy, Viscountess Cranbrook, was founder-chairman of the festival), and stayed at their home Great Glenham House. Here he attended summer afternoon concerts in the drawing room; Julian Bream played, as did the American-born pianist Hephzibah Menuhin, while Pears sang and Britten set Arthur Whaley's Chinese translations to music.

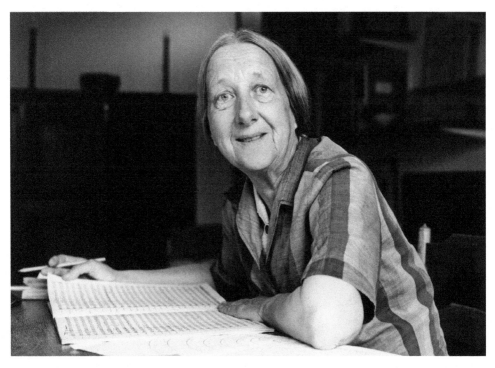

Imogen Holst at her home in Church Close, Aldeburgh. (Courtesy of the Britten-Pears Foundation)

Britten wrote *Let's Make an Opera* for the Cranbrook children, whose names were taken by Crozier, the librettist, and they played the leading roles in the internal opera *The Little Sweep.*

Cranbrook (later a Framlingham magistrate) introduced Blythe to Britten and Pears, who offered him a cursory interview – both wearing shorts – and made him Imogen Holst's assistant at £150 a year. In 1956 he edited the lavish festival programme book, which had essays, photographs, drawings and engravings alongside details of all the concerts.

Blythe worked at the festival with Imogen Holst, a musician in her own right and only child of the composer. She had come to Aldeburgh in 1952 and was the festival's artistic director from 1956 to 1977. She lived at first in a flat in the High Street and later at No. 9 Church Walk, near the church. She died in 1984 and is buried near Britten and Pears in the churchyard of St Peter and St Paul.

Blythe had a musical part to play too, singing Britten's 'Saint Nicolas' cantata when it was first performed in Aldeburgh Church.

David Hemmings, then twelve years of age and later an international film star and director, was cast by Britten in 1954 as Miles, one of the children in his operatic version of Henry James' *The Turn of the Screw.* Hemmings lived for some months at Crag House and Britten showed every consideration for him regarding his voice and his need to rest, but he also appears to have developed an infatuation for him, which Hemmings recognised and of which Pears was aware. Hemmings, though, described Britten as 'incredibly warm' and 'a gentleman' from whom he never felt any sexual threat, and was ever grateful for his work with Britten.

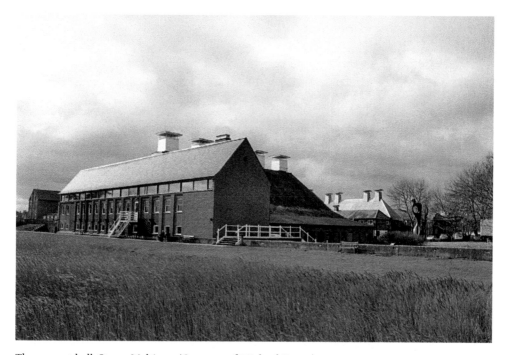

The concert hall, Snape Maltings. (Courtesy of Michael Rouse)

Hemmings' stage debut in the role was at the premiere of an opera in Venice. He toured Europe with the English Opera Group, which Britten had founded with Crozier and the artist and set designer John Piper. In 1956, when he was fifteen, Hemmings was playing Miles in Paris when, in the middle of the aria 'Malo', his voice broke. Britten stopped the orchestra, put down his baton, and the curtain was brought down. Britten never spoke to Hemmings again. For all his ease and kindliness, Britten was also known for his ruthlessness and suddenly cutting people off (as he was to do with Crozier).

Twenty years later, the composer Colin Matthews (whose brother David, also a composer and later married the novelist Maggie Hemingway – *see* Chapter 6) was working as Britten's assistant from 1971 until 1976. He assisted Britten on the opera of Thomas Mann's *Death in Venice*. He detected autobiographical elements in this connected with Britten's relationship with Hemmings. 'There is still a dark side to the work that I still can't understand,' he suggested to Britten's biographer Humphrey Carpenter.

DID YOU KNOW?

The bricks of an attractive red-brick, arched bus stop just past the turn-off to Snape from the Farnham–Aldeburgh road are from the 1802 narrow, single-arched, humpbacked bridge that was demolished in 1959.

The bus stop near Snape.
(Terry Philpot)

In 1971 Susan Hill, by then established as a novelist (her first novel came out in when she was at university), visited Aldeburgh. Since her late twenties she had been 'overwhelmingly affected by Britten' since she had first heard the 'Sea Interludes' from *Peter Grimes* when a schoolgirl in Coventry, and had become 'obsessed' by the opera itself.

Her visit was brief but produced her novella *The Albatross*, where Aldeburgh appears as Heype. Myfanwy Piper, who acted as a librettist for Britten and knew Hill, thought that the book would interest the composer and so sent him a copy of *The Albatross and Other Stories*.

Hill came back to Aldeburgh to rent a cottage that same year, now working on *Strange Meeting*, a novel of the First World War, having been 'dazed' by Britten's *War Requiem*. Britten invited her for lunch at the Red House, where another guest was Mary Potter. Pears immediately made Hill feel at home – out of the couple, he was the one she always found easiest to talk to. Of Britten, she said, 'He was immediately so charming that I didn't feel the least overawed.' She went on to relate, 'What struck me was the obvious, natural domestic affection between Ben and Peter. I remember thinking that this was a perfectly ordinary relationship which just happened to be between two men.'

Britten died in 1976 after a debilitating illness and Pears a decade later, having suffered a stroke five years before. The two lie in the churchyard of St Peter and St Paul, next to each other beneath slate headstones – united in death as they were in life and music.

6. Many a Fine Art

While the years of Philip Wilson Steer, Charles Rennie Mackintosh and their contemporaries tend to define Walberswick's reputation as a magnet for artists, they were neither the first nor last to have found the village, its hinterland and the sea attractive. Cornelius Varley, Peter de Wint and others were in Walberswick in the early eighteenth century. Charles Keane had known Southwold and Walberwick since the 1860s, and the English marine painter Henry Moore had also worked there, as had Walter Osborne. Stanley Spencer stayed at Wangford and painted *Southwold* in 1937, among other works. He and his first wife, the painter Hilda Carline, married at the Church of St Peter and St Paul in 1925. Julia Laden lived at Brudenall House in Aldeburgh, and Peggy Somerville also lived in the town in the 1950s, as did Mary Potter (*see* Chapter 5).

Philip Wilson Steer

In 1884, and for every summer for at least a decade, Steer left London to draw landscapes and seascapes. His destination would often be Walberswick. He made a number of paintings of the beach, which are judged to be among the most authentically Impressionist works produced in Britain. They contain the familiar characteristics of the school: the effects of light and atmosphere. When paintings like these were exhibited for the first time in Britain in the 1880s and 1890s, they were seen as avant-garde. Indeed, his biographer Bruce Laughton wrote, 'His early paintings at Walberswick, Boulogne and elsewhere are among his most original and unorthodox works.' Some, however, found his work 'objectionable.'

Girls Running, Walberswick Pier, The Beach at Walberswick, Figures on a Beach, Walberswick, Children Paddling, Walberswick and *Southwold* are some of products of Steer's productive time in that part of Suffolk.

Steer had always been a painter, although occasionally he taught painting, too. He never married, but there is no doubt that he had romantic relationships: one of his more popular portraits, *Girl Reading a Book,* is of his one-time lover the model Rose Pettigrew.

One of his most notable paintings of the Suffolk years is *The Bridge*. In it a woman stands with her back to the viewer looking across the estuary, with boats in the distance, while a man stands beside her, apparently talking. Her posture suggests she may not be listening or, conversely, listening very intensely.

This picture inspired Maggie Hemingway's 1986 novel of the same title about Steer. Hemingway had a love of Suffolk. Although born in Orford in 1946 and taken by her parents to live in New Zealand when she was two, upon returning she never again lived in the county. However, her partner David Matthews, a composer, remembered that 'whenever we travelled to Suffolk by train and crossed the Stour at Manningtree she would say something like "Now I'm home again".'

In the book, which became a film in 1992, Hemingway has Steer staying in the village in the summer of 1887, sketching and painting. Isobel Heatherington, an attractive but – as we learn – very unhappily married woman, and her three young daughters have taken Quay House, which Mr Heatherington visits only occasionally. Steer falls in love obsessively at first sight and gradually learns that Isobel reciprocates his feelings. The relationship is intense, mostly unspoken and never consummated. The book is written in an almost painter-like way, suggestive of the natural light of Impressionism. But discovery and propriety cause a tragic ending.

What to make of this? Hemingway's preface says that she noticed how Steer's work lost vitality, directness and freshness after he ceased to come to the village in 1891. This led her to invent this doomed love affair as the reason for these changes. All the characters are fictitious, with the exception of Steer, Walter Sickert, Charles Shannon and Dolly Brown. Brown, a local young woman who acts as the children's nanny, modelled for Steer as she did in real life. *Dolly Brown in Front of an Apple Tree* has sadly been lost, but she appears with her sister Emma in *Girls paddling, Walberswick*. Both sisters later married artists: Emma to Walter Cadby, and Dolly to Frank Morley Fletcher.

Either at the premiere of the film or an earlier launch party, a man approached Hemingway and asked how she knew of the affair. She said she didn't and she had invented the story, whereupon the man introduced himself (according to her obituarist Jane Gardham) as the illegitimate son of Steer – the son would have been in his nineties when the book and the film came out. 'Although Maggie invented the story she wasn't surprised to discover that it had a basis in truth,' her husband David Matthews told me.

Charles Rennie Mackintosh

The First World War had three great effects on the life of Charles Rennie Mackintosh, Scottish architect, designer and painter. The first was that he and his English wife Margaret, herself a noted watercolourist, were planning to accept invitations to visit Paris and then travel to Berlin and Vienna, but the outbreak of war on 4 August 1914 put paid to that.

They were holidaying in Walberswick that July, staying in Millside, owned by the Nicol family and semi-detached to a house owned by their friends, Francis and Jessie Newbery. (She was an artist and embroiderer, and he was a painter and director of the Glasgow School of Art, whose design he had commissioned from Mackintosh.) When the war broke out, Mackintosh, although depressed from lack of work and having wound up his architectural practice, never intended to leave Glasgow, but, as his biographer Alan Crawford says, 'somehow, they never went back'.

Now more permanently settled in the village (or so they imagined), Jessie found them a studio, which was no more than a fisherman's shed overlooking the estuary.

The second effect of the war was that Mackintosh moved from architecture to painting water colours, especially flowers. Forty of these date from this time – 'quite straightforward, frank work,' he described them to a friend. While he did sketch some houses, *Venetian Palace, Blackshore on the Blyth* (1914) is said to be one of the few Walberswick paintings that is not a flower study and is the last known work by Mackintosh to be exhibited before he left England in 1923 – the year it was shown at the Royal Academy.

Spurge, Withyam by Charles Rennie Mackintosh. This is the kind of work to which they turned their attention in Walberswick, although this was painted in East Sussex.

Margaret wrote to their friend Anna Geddes, wife of Patrick, the geographer, botanist and town planner: 'Already Toshie is quite a different being and evidently at the end of the year will be quite fit again.'

The third effect of the war were the events that interrupted this creative Walberswick life. He and Margaret rarely went out to meet friends – if people wanted to see them, they came to Millside. When the Newberys moved back to Glasgow, the Nichols moved into

Millside, causing the Mackintoshes to move to Westwood in Lodge Road. The garden was capacious enough to provide Mackintosh with subjects. He worked during the day and in the evenings would drink in the Anchor Inn or the Bell Inn and later walk on the beach by the water.

Blucher English, then a child, told Moffat in 1984:

> I must have been playing near the ferry and I saw this man coming, dressed like Sherlock Holmes ... He didn't seem to notice the waves washing around his feet ... He had a big face, not a fat face, but a big face and really piercing sort of eyes.

While Mackintosh was friendly with children – such as Blucher English and the Newbery's daughter, Mary, who had known him in Glasgow – he did not mix much in the pub, although he seems to have been popular: the locals called him 'old Mac' and their housekeeper Phoebe Thomson liked the couple enough to name her daughter Margaret.

When people heard him speak it was said they were puzzled by his accent. It couldn't be Scots because he did not sound like the 'herring girls' who came from Aberdeen to help gut the fish that came in from Southwold, Walberswick and Lowestoft. They noted, too, that Margaret was English and would often leave the village by train, leaving her husband behind. Where did she go?

At a time of strong anti-German feeling, any suspicions became facts, any fantasies found a place, and anybody unusual became a potential enemy. That must, then, be a German accent with which Mackintosh spoke. Such reasoning flourished the more when one night with Margaret away Mackintosh was having trouble with a flickering lantern at a window. Was this a signal to Germans off the coast? 'Dinks' Cooper, a local fisherman but then a child, claimed his elder sister – in service locally – had seen the lantern and reported it to the police.

One evening Mackintosh returned from his nightly walk to find a soldier outside the house with a fixed bayonet, and inside there several soldiers carrying out a search. A clutch of letters were found, which were written in German (Margaret spoke the language) from a firm of Viennese architects offering Macintosh a job.

This was enough to confirm suspicions. Mackintosh spent the night in a police cell in Southwold, but refused to answer any questions. The letters were kept for five weeks and were enough to warrant an arrest. When Margaret returned she fell ill with worry, but Geddes vouched for Mackintosh.

He was brought before the Southwold magistrates and ordered not to live in Suffolk, Norfolk or Cambridgeshire, or near main roads, rail stations or on the coast.

He left for London and found temporary work with Geddes. When Margaret joined him in August 1915, they set up a studio in Chelsea. In fact, Mackintosh later came back to Walberswick on his own to paint – sometimes cottages and sometimes buildings by the river. He stayed at the Anchor Inn, where he had to share a bed with Ginger Winyard, the innkeeper's son, and he may also have stayed with the Thompson family at Lorne Cottage.

In 1923 the couple moved to Port Vendres in southern France, which was cheaper and warmer. Mackintosh gave up architectural work and continued to paint. However, in 1927

his ill health forced them back to London, where, diagnosed with cancer of the tongue, he died on 10 December 1928.

The Ropes: Art in the Family

Ellen Mary Rope, George Thomas Rope and Edith Dorothy Rope were three of the nine children of George Rope, a corn merchant and farmer of Grove Farm, Blaxhall, and his wife Anne. George was born in 1846 and became a naturalist and professional landscape painter. Ellen was born in 1855 and was a sculptor, known for her work mainly in bas-relief, stone, cast metal or plaster. Edith, a painter, was born in 1857.

This remarkable artistic flowering followed in the next generation for their niece Dorothy Anne Aldrich Rope, a sculptor, shared a London studio with her aunt Edith in 1903. Dorothy's sister was M. E. (Margaret Edith) Rope, and Dorothy and Margaret were cousins of Margaret Agnes Rope of Shrewsbury, who worked in the field of stained glass but in the same tradition.

Ellen Rope attended school in London and studied at the Ipswich School of Art. In 1876 she began exhibiting paintings and ceramics at the Ipswich Fine Art Club and joined the Slade School of Fine Art in 1877. Her painting and drawing gave way in 1880 to studying sculpture and modelling. She collected several prizes and in 1885 the Royal Academy accepted her terracotta relief *David Playing before Saul*. She also exhibited elsewhere, producing four large wall sculptures for the Women's Pavilion at the Chicago World Columbian Exposition in 1893.

She was inspired by classical works and in 1896 became a designer with the Della Robbia Pottery at Birkenhead. Her reputation increased through further exhibiting in London, Ipswich, Liverpool, Manchester, Glasgow and Paris. She was awarded prestigious commissions in churches (which included Salisbury Cathedral and the war memorial in St Peter's, Blaxhall) and other public places. For the popular market she depicted children and fairies.

Although Ellen Rope lived and worked in London for most of her professional life, other examples of her work can be seen in Suffolk: a plaster group in St Peter's, Blaxhall (1911), and the holy family and St Michael at Kesgrave, Suffolk (1932). She created the marble memorial to Louisa Garrett in Aldeburgh parish church, having known the Garretts since childhood (*see* Chapter 3). She was unmarried died at Grove Farm in 1934 and was buried in the graveyard of St Peter's Church.

George's interest in animals stemmed from childhood. At Ipswich Grammar School he studied natural history and developed a keen interest in art. He went to London in his teenage years and studied in an artist's studio before returning to Suffolk. He sketched in pencil, produced water colours and oils of landscapes and animals. He wrote books on trees, mammals and the Suffolk dialect, and also wrote poetry. He not only worked in his native county, but toured England and exhibited with the Ipswich Art Society and at the Royal Academy. He was never physically strong and his health grew worse with age. He died when he was eighty-three after the trap in which he was travelling overturned near his home.

Margaret Edith Rope was born in 1891 in Leiston, one of eight children. To distinguish herself from her older cousin who had the same first name and surname, she adopted

Margaret Edith Rope's lancet in St Mary Magdalene's Church, Bolney, West Sussex. (Courtesy of Antiquary under Creative Commons 4.0)

her mother's maiden name and called herself M. E. Aldrich Rope or M. E. A. Rope. In the family she was known as Tor as she used a tortoise signature in some of her windows.

She proved to be a very prolific artist in stained glass. She was educated at Wimbledon High School and Chelsea School of Art and LCC Central School of Arts & Crafts. In 1911 began working with the older Margaret Agnes Rope at the Glass House, Fulham, a purpose-built stained-glass studio and workshop for independent artists.

Much of M. E. Aldrich Rope's work was in Anglican churches, as well as some Catholic ones. It can be seen in Australia, Malta, Sri Lanka and Trinidad. Her windows can be seen in many parts of England, including London churches and seven Suffolk churches, and one each in Wales and Scotland.

For most of her professional life she lived at various addresses in South London. Later in life she converted to Roman Catholicism and in 1978, when she was eighty-seven, she moved to live on the family farm in Suffolk. She was ninety-six when she died after a long period of suffering from Alzheimer's disease.

Margaret Agnes Rope was born in Shrewsbury in 1882, first daughter of Henry John Rope, a brother of Edith, George and Ellen. The family was in difficult circumstances when her father (a doctor) died young in 1899. Her mother converted to Roman Catholicism soon afterwards but Margaret's maternal grandfather had denied a legacy to any of his children 'in religion'.

Margaret was educated at home and then studied at Birmingham Municipal Art School. In 1923, having converted to Catholicism from Anglicanism much earlier, she entered the Carmelite Order as a nun, becoming Sister Margaret of the Mother of God. Her sister Monica also entered the religious life and her brother Harry became a priest.

As Sister Margaret she was an enclosed nun at the Carmelite's house at Woodbridge, Suffolk, but she continued her art and used to send glass to the Glass House for cutting, firing and leading up. Her work supported the community financially. In 1938 she moved with the community to Rushmere St Andrew, near Ipswich. In 1948 the community moved again – to Quidenham Hall in Norfolk. Her work in stained glass came to an end, apart from some designing and illustration. She died on December 1953. There is a memorial window to her in the Kesgrave Church.

Dorothy Anne Aldrich Rope was the sister of M. E. Aldrich Rope and was born at Blaxhall in 1883. When she was twenty-seven she lived in London with her aunt Ellen. She joined the Ipswich Art Club in 1928, remaining a member until four years before her death. She exhibited at the Walker Art Gallery in Liverpool and the Royal Academy, and produced pottery and bas-relief but also some notable three-dimensional sculptures, often using religious themes. She designed the war memorial at St Margaret's, Leiston. In 1939 she was an art teacher in Kettering, Northamptonshire. She never married and died at Leiston in 1970.

Kenneth Clark

Clark, one of the twentieth century's most influential voices, became director of the National Gallery in 1933 at the age of thirty. He went on to become a historian, writer, inhabitant of committees and numerous public bodies, and creator and presenter of the award-winning television series *Civilisation*. His wealthy parents owned a country home

in Scotland and wintered in another home on the French Riviera, but their son regarded Sudbourne Hall, near Orford, as his childhood home and it was there that shoots of his later aesthetic appreciation started to come through.

His parents were vastly different in personality, although the marriage was a fond one. It was his Scottish nanny Miss Lamont ('Lam') from whom he received affection and came to adore.

His father, also called Kenneth, paid £237,500 (with a mortgage of £75,000) a year after his son's birth for the house and its 11,000 acres, which included a model farm and several villages. Clark Jr delighted in the Suffolk Punches, part of the noted Sudbourne Stud.

Sudbourne Hall was built by James Wyatt in 1784 for the first Marquess of Hertford. Clark described it as 'featureless, set in the cold East Anglian countryside'. His father bought the house for the large amount of game available for shoots. 'He was an excellent shot,' wrote Clark of his father, 'and he was determined that his guests should have the opportunity of shooting more peasants than anywhere else in Suffolk.' Clark did not like shooting and was distressed when the birds were brought in. His father was a sportsman, a gambler and, ultimately, an alcoholic. His son described him as both rich and idle, although he built the cottage hospital in Orford. The younger Clark entered the library one day to find two men, one of whom may have been Maundy Gregory, Lloyd George chief vendor of honours, obviously offering his father the chance to buy a peerage. 'Wouldn't you like this little chap to succeed you?' asked one. 'Go to hell,' said Clark Snr.

Clark's appreciative eye was evidently apparent as a child. He remembered:

> The long, irregular line of the street that winds down from Orford church to the harbour gave me (and gives me) inexplicable pleasure, although I can think of nothing like it in a painting. The sight of yachts on the Alde delighted me long before I had seen an Impressionist picture. Equally, with architecture, and I am reluctant to consider architecture independently of its setting, I fell in love with the Maltings at Snape at the age of seven, although no one told me then that there was anything remarkable about them; indeed, no one mentioned them until Benjamin Britten decided to build a concert hall there.

The house was 'a large, square brick box, with a frigid, neo-classical interior'. Advised to make it more comfortable, his parents hired an architect, went abroad and returned to find the main hall, galleries and staircases transformed into neo-Jacobean style. As Clark remembered, 'There were pheasants, partridges, woodcocks, squirrels and spaniels, all in high relief. It was in very bad taste, but may well have been warmer and friendlier than Wyatt's neo-classicism.'

When his parents took the cure in Carlsbad or Menton Clark went back to Sudbourne, sharing it with resentful servants. But the library was some kind of compensation and he read widely from Voltaire (in the original) to Aubrey Beardsley. The books were inherited from the previous owner – Clark doubted his parents ever bought a book except to give him – and he revelled in the library's warmth and cosiness, and at being surrounded by books. He also liked the billiard room because it contained a pianola organ on which he could play Rossini's 'Stabat Mater' and Mendelssohn's 'Elijah'.

Clark's escape from Sudbourne was to Castle House, which overlooked Orford Castle. His father had built it for his grandmother, who lived there with her eldest daughter. It was 'a haven of peace, order and predictability' that Clark found in contrast to the extravagance of the family home. It was also the occasional escape for his father: 'After a heavy bibulous house party, in order to avoid a scolding, my father would trot out to Castle House, in very poor shape, and they would receive him calmly, as if nothing were amiss. He was infinitely grateful to them.'

He attended Orford Church from an early age, but attendance fell away because his parents were reluctant attendees. His mother came from a Quaker background. Clark describes his father's churchgoing, saying that his father was large and the church small and so when he entered the nave 'it seemed as if the ship of Christ would founder'. The organist would stop, the choir would cease singing and the priest would fumble with his words. 'After a few minutes my father stalked out, bored and disgusted'.

Clark remembered bombs falling on the park. In 1917 Clark's father put the house on the market. Not finding a seller, lots of land went at an auction. Then in 1921 Joseph Watson, soon to be the first Lord Manton, bought it with reduced acreage for £86,000. Sudbourne Hall was demolished in 1953.

7. When Disasters Struck

Fire in Southwold

Southwold's 'greens' result from the fire of 1659, which destroyed much of the town. It is estimated that 459 buildings were lost and, rather than rebuild on the now-empty sites, they were left to form firebreaks should such devastation threaten again. It is said that the ruins of the destroyed properties lie beneath the greens and that South Green marks what was once the centre of the old town.

The fire destroyed the town hall, the town's records, its prison, marketplace, granaries, shops and warehouses, causing severe economic depression and leaving local people in poverty. A thirteenth-century chapel was destroyed on the site in the early fifteenth century – very likely also by fire. This time the church was severely damaged.

Aldeburgh Lifeboat Disaster

Communities that live by the sea acutely feel the loss of life when a boat goes down – perhaps even more so when it is a lifeboat. An irreparable tear is made in the community. This was never more so when, on 7 December 1899, the crew of Aldeburgh's lifeboat, *Aldeburgh*, was summoned at 11 a.m. by distress signals during a heavy storm.

The boat was having problems getting past the shoals and as it attempted to cross the inner one, two great waves struck its broadside. It capsized, turned upside down and came to rest on the beach.

Of the eighteen crew six were trapped in the overturned hull, one of whom was twenty-one-year-old James Miller Ward, who was washed out from under the boat and efforts to revive him failed. Three hours after attempts to raise the 13 tonne *Aldeburgh* failed, a hole was made in the hull but the five men trapped inside were dead. It was not until the evening that the boat could be raised and levers used to free the last body.

The dead crewmembers were James Miller, who was married with a son and his was wife pregnant with their daughter; fifty-one-year-old widower and father of six, Charlie Crisp; twenty-three-year-old Herbert Downing; John Butcher, a fifty-two-year-old father; Thomas Morris, thirty-six; and Walter Ward, thirty-three and married with two children. Allan Easter, aged twenty-eight, was rescued from the sea but later died of his injuries.

The Coxswain, Charles Ward, vividly recounted:

A very heavy sea caught her from stem to stern. We were right under it. The boat was filled, and was forced over on the starboard side. Then another very heavy sea struck us, and the boat went over steadily. The boat could not right herself. I got clear of her, and when I could see round there seemed so many of us afloat that I thought all the men had got clear.

We were about 150 yards from shore and could all swim. I said to one man, 'Don't muddle yourself; we shall get ashore all right,' but as we got on the beach the waves rolled us up like so many sacks.

The first to be washed ashore, Ward returned time and time again to drag his comrades to safety in what has proved to be one of the worst disasters in the history of the Royal National Lifeboat Institute. The following year Ward received his second Silver Medal for Gallantry from the RNLI.

A relief fund was opened for bereaved families and a marble monument stands in the Church of St Peter and St Paul, where the men were buried. There is a copper memorial inside the church.

A pocket watch – which stopped at 11.31 a.m., the time when the *Aldeburgh* capsized – belonging to a survivor named Augustus Mann can be seen in the Aldeburgh Museum.

Mann is also responsible for a superstition that arose that day which persists 118 years later. He and his brother Dan were crew members and Augustus put their good fortune at surviving down to the three acorns he carried as lucky charms in his pocket. Today those acorns, now in a glass-fronted box, made from an early seventeenth-century oak frame from the Moot Hall, are carried on the town's lifeboats.

The Floods of 1953

The coastal corridor that links Southwold to Aldeburgh was not alone in being affected by the floods and storms of 31 January to 1 February 1951. Thirty-one people died in Suffolk, where the flood reached 2 miles in land, and 307 died in England. The total affected area ran from as far north as Scotland to the Royal Docks in London. They even struck the Netherlands and Belgium.

Floods had badly affected the corridor in November 1887, January 1928 and February 1938. Southwold, where five people died, was particularly ill-served in 1953 by its one route that caused the town to be cut off for forty-eight hours. In Aldeburgh dead cattle floated in the streets. Slaughdon's quay to the south was particularly badly hit and 8-tonne yachts on the Alde were battered.

By the end of 1949 the Catchment Board had built defences from the White Lion Hotel to the Brudenell Hotel in Aldeburgh, but these proved of no avail four years later.

A 35-yard breach appeared in the wall of the River Alde and a thirty-five-year-old fisherman named Daniell Mann died, but two other fishermen were rescued. Two soldiers were rescued and two others taken to hospital when, with others, they were sucked through the breach they had been seeking to repair.

Two days after the storm, Reginald ('Regi') Raffles wrote to an aunt from the Swan Hotel in Southwold, where he, his Dutch wife Josie and three children had been given a week's free accommodation:

> We are all alive and lucky to be so. Financially, we are practically ruined, as the insurance will not probably pay-up – flood damage. Our only hope is that the Government will give us something.

The Dutch Barn [a restaurant his wife ran], except for the flat, is ruined and one bungalow completely destroyed. The other bungalow is full of water and none of the furniture will be any good. Our car is upside down in the flood. The value of this we may recover ...

There had been a tremendous gale for 24 hours and there was also a very high spring tide. At about 9.15pm the sea started to pour over the dune into the road and in five minutes' time it was running like a mill-race right up to the windows of the first floor. Escape was impossible and we could only pray that the house would not collapse.

There were six buildings on the road beyond us – at about 11 o'clock I looked out of our drawing-room window and all except a fragment of our own bungalow were gone.

Five people were drowned. The whole road is a waste of smashed furniture, debris of houses and countless tons of sand and shingle. Our garden is completely swept away ...

At about 2.30am, the tide went out and some men came along with planks etc and got us out through a window. The worse night I have ever been through. Bombs were nothing to it...

Several people were awarded the British Empire medal for their part in rescues, one of whom was an Aldeburgh fisherman named William Burrell, who rescued four men when their boat capsized.

Ronald Blythe, living in Thorpeness two years later (*see* Chapter 5), wrote that 'the signature of the great 1953 flood ... was writ large wherever I went'.

8. Bloomsbury near the Sea

When conscription was introduced in 1916 during the First World War, almost every male member of the Bloomsbury Group eligible for call-up resisted. The one exception was Ralph Partridge, future husband of Frances Partridge (later a Bloomsbury memoirist), although he was not a member of the group at the time and he later resigned his commission on moral grounds.

David 'Bunny' Garnett, later a novelist and the only child of Constance (the translator of the Russian classics) and Edward (the publisher's editor and writer), had no qualms about spilling blood. He was not as pacifist. His objection, he said, was in delegating his conscience to the state. He volunteered to work for the No Conscription Fellowship, the main vehicle for conscientious objectors, along with some others of the group. Most of Garnett's non-Bloomsbury friends signed up.

The painter Duncan Grant (Garnett's lover) was also an objector, and his father Major Bartle Grant referred to Garnett as 'your friend Garbage'. One way to seek exemption was to undertake work of national importance. Advised by the economist Maynard Keynes as to what they might do, Grant and Garnett believed that they might fall into this category if they took up fruit farming at the small village of Wissett, near Halesworth. The farm had belonged to the late cousin of Grant's mother and for whom his father, as executor, was seeking a tenant.

While registering at his local tribunal in St Pancras, London, Garnett was serious about farming. He asked his mother about sowing crops (he proposed growing several hundredweight of potatoes) and said he intended to keep 100 hens and a large flock of geese. But of fruit farming he knew nothing, and Grant knew far less than he did.

Wissett had a main street, a church and then two pubs. The farm was half a mile away, a wisteria-covered early Victorian house with small, dark rooms. Garnett stayed at the Swan Inn while trying to make the house habitable, but Grant caught a cold and was summoned to bed in London by Vanessa Bell, Virginia Woolf's painter sister.

Grant being in London was no brake on Garnett – there were beehives to be disinfected and currants to be pruned. A lover named Barbara Hiles moved down and though he could now live in the house, she stayed nights in the Swan Inn 'to keep on the right side of village gossips'. At Easter he expected another lover, Ruth Baynes, to appear (he and Hiles would have a lifelong friendship and an on – off affair). He told all this, in typical Bloomsbury openness, to Grant, who hoped to have his lover to himself when he came back to Wissett.

That happened in March 1916 and the next month Vanessa came with her children – Quentin and Julian – and servants, Flossie and Blanche. News arrived that the tribunal to

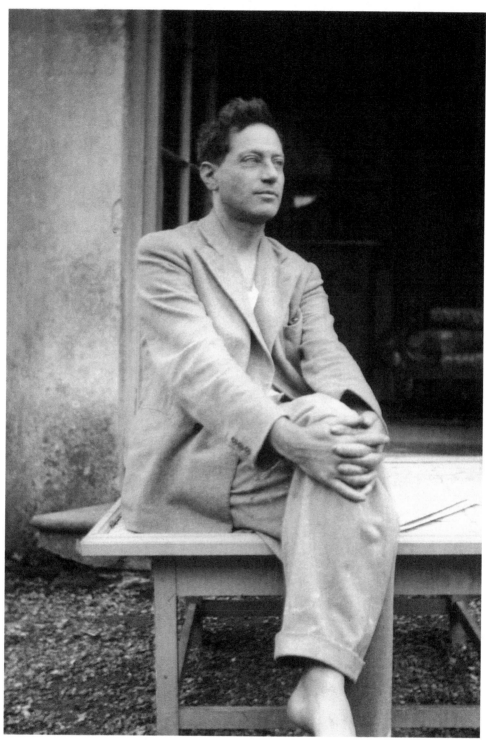

Duncan Grant. (Courtesy of the Charleston Trust)

Vanesa Bell around the time she visited Wissett.

hear Grant and Garnett's cases would be held at Halesworth and not in London. Garnett became irritated and dismissive when his mother sought character witnesses to support him at the tribunal: she was spoiling his chances by making him nervous, he protested.

While Garnett told his mother at this time that 'the best informers' believed the war would end that autumn or late summer, a Zeppelin was seen over the house and bombs were heard to explode nearby at Wangford.

Grant dyed the fowls blue, and sixty bunches of daffodils were cut and sold for 4s (20p) in Norwich, to which the two men cycled. Lunch cost 6s and bike hire 2s, but they were independent. Garnett enjoyed farming and Grant and Bell painted and also decorated Wissett Lodge with frescos and figures.

The rabbits came indoors in the cold, farming manuals were read without profit and there was a plague of fleas. They found undiscovered orchards and there were far too many blackberry bushes to deal with. On his twenty-fourth birthday Garnett found all his bees dead. Keynes gave him a loan and he bought Italian bees. Edward and Constance came to stay; he said it was a jolly place, but she was more practical with suggestions about poultry and vegetables.

Clive Bell, Vanessa's husband, came with his mistress Mary Hutchinson who was, understandably, put off by the fleas. The literary hostess Ottoline Morrell loomed in on a visit and found it all dark, damp and untidy. Garnett, she said, 'has quite the look of a farm labourer now'.

He told his mother he had an aptitude for farming and might take it up after the war. But the work took its toll in exhaustion, with Garnett undertaking most of the work. He could not plan ahead and so the viability of the farm came into question.

Garnett and Grant appeared at Halesworth on 4 May. Garnett barred his mother and father from attending as he had expected to be sent to prison. He regarded the tribunal as 'a farce'. The application was refused but the two appealed. Locals remained suspicious: only a few miles away Charles Rennie Macintosh would be hounded as a spy in Walberswick (*see* Chapter 6). In nearby Henham, a school teacher met the same fate because his son had entertained a German penfriend.

At the appeal in Ipswich on 19 May, Keynes demanded that the case be dealt with 'expeditiously' as the two were engaged in work of national importance, while Ottoline Morrell's husband Philip Morrell MP gave testimony. They were given non-combatant service in the army and another appeal was launched.

The next month the gay writer Lytton Strachey came for a weekend 'as much to see me as any of the others', said the muscular and handsome Garnett. Strachey wrote of Garnett's charm, sympathy, shyness and animal magnetism. There was some kissing, but Strachey also implies earlier there had been more serious physical contact. Strachey confessed in

David Garnett in later life.

the garden at Wissett to Garnett that he had fallen in love with the artist Dora Carrington. While all this was happening Garnett was also trying to write, but a Board of Agriculture inspector could not recommend the farm work as that of national importance.

However, when Vanessa Bell left Wissett in September 1916, she took a lease on Charleston Farmhouse in Firle, Sussex, which she and Grant would also decorate it with figures and murals. This allowed Grant to tidy up in Wissett and Garnett to leave to work for a local farmer in Sussex, leaving with Hiles and Carrington.

Garnett had 'fallen in love with working on the land' at Wissett. He went onto become a novelist, husband and father and one of the last survivors of Bloomsbury, but his life at Wissett showed in the farming, planting, and vegetable and fruit growing at Hilton Hall in Cambridgeshire, his last home in England. He spent the last ten years of his life in France, where he died aged nearly ninety.

9. Mixed Characters

Lady Katherine Grey

Henry Grey, Duke of Suffolk, was executed in 1554 for his part in the short-lived rebellion by Sir Thomas Wyatt to overthrow Queen Mary Tudor when she announced her marriage to Philip of Spain. Grey was the father of Lady Katherine and Lady Jane Grey, granddaughters of Mary, sister of Henry VIII. Jane was executed that same year and is known as the 'Nine Days Queen', having been declared queen in 1553 at the death of Edward IV and usurped by Mary Tudor, who had mustered her forces at Framlingham Castle.

Katherine was heir presumptive under Henry's will as both his daughters, Mary and Elizabeth, the Greys' cousins once removed, had been declared illegitimate.

Katherine wished to marry Edward Seymour, Earl of Hertford. Her mother died before being able to seek the permission of Elizabeth (necessary as Katherine was of the royal blood), who had succeeded Mary to the throne. Katherine and Edward went ahead with royal consent and married in 1560 (she was pregnant). Elizabeth sensed a plot and Katherine and her husband were imprisoned in the Tower of London, where their sons Edward and Thomas were born and baptised. In 1662 the Seymours' marriage was annulled and the boys declared illegitimate – removing them from the line of royal succession.

Separated from her husband, whom she never saw again, Katherine spent the rest of her life imprisoned. In 1657 Elizabeth ordered that Sir Owen Hopton, lieutenant of the tower, take Katherine and her sons to Cockfield Hall, near Yoxford, his family home, to recover from her privations in the tower. It was to be her fifth prison in seven years. Elizabeth instructed that Katherine was to be completely isolated. She was not to dine with the Hoptons or receive guests of her own. It would have been little consolation that her chamber was described as 'a very fair room'.

Her husband met her expenses with 66s 8d per week for her meals, 26s 8d for his sons and 6s 8d for each of her seventeen attendants. The rents of the college at Astley in Warwickshire were assigned to Katherine by the queen in 1567 to supplement her modest income.

Sir Owen disliked the responsibility thrust upon him, but he liked Katherine and was worried at how pale and thin she was and she appeared to be depressed. He sent to London for her doctor, who came twice, and she temporarily rallied. Katherine died on the morning of 27 January 1568. The previous night she had said she was dying and spent the night saying the psalms or having them read to her. Lady Hopton tried to comfort a twenty-seven-year-old whom the Hoptons were shocked to find so fatalistic.

Katherine was buried in the Cockfield Chapel in Yoxford Church. Her grandson later reinterred her remains in the Seymour tomb in Salisbury Cathedral, where she rests beside her husband. In 1606 their marriage was declared legitimate.

Elizabeth I, cousin to – but nemesis of – Lady Katherine Grey.

Cockfield Hall, Yoxford – Lady Katherine Grey's fifth prison and where she died. (Courtesy of R. Haworth under Creative Commons 3.0)

Edward Clodd, Thomas Hardy and Agnostic Whitsuns

Apart from the fact that he was separated from Eliza, his wife and mother of his eight children, Edward Clodd's life might seem conventional. He was born in Margate, Kent, in 1840, the eldest and only surviving child of seven. As baby he moved to Aldeburgh, which is where his parents were from. He attended a local dame school and then Aldeburgh Grammar School, and attained an early love of reading from his mother.

In 1916, he wrote, 'Seventy years ago, Aldeburgh ... retained many of the features of an old fishing and smuggling port which are described with the minuteness and fidelity of a Dutch painting [and] in Crabbe's *Borough*.' He remembered how schoolboys gathered at the town's reading room in 1854 to have Mr Dowler, the vicar, read news of the Crimea War from *The Times.*

His parents were Baptists and the chapel was strict and literal. Clodd was intended for the ministry, but he spent all his working life in the city. He began working in an accountancy firm in London when he was fourteen and retired when he was seventy-five from the London Joint Stock Bank, which he had joined in 1862.

His parents owned Strafford House at No. 33 Crag Path in Aldeburgh, which he inherited and after retirement lived there permanently. He had it decorated by the Arts and Craft architect and furniture and textile designer Charles Voysey.

Left: Edward Clodd, writer and centre of a freethinking circle. (Courtesy of Wellcome Images under Creative Commons 4.0)

Below: Edward Clodd's house, Aldeburgh. (Terry Philpot)

But Clodd had another life against the one of outward prosperous convention. He moved from Baptist faith to Congregationalism and then to Unitarianism and finally to agnosticism, deeply influenced by science and Darwin. He established himself as one of the leading rationalists of his day and became chairman of the Rationalist Press Association in 1906. He wrote several well-regarded books on religion. His first book, *The Childhood of the World*, was a primer on evolutionary anthropology and sold widely, including in two African languages. *The Story of Creation* sold 5,000 copies in three months and made him wealthier. In 1861 he also wrote, anonymously, his *Guide to Aldeburgh*.

To further his ideas, he held Whitsun gatherings at Strafford House for intellectuals of his philosophical bent, evidence of his 'genius for friendship' noted by the novelist Thomas Hardy. Clodd oozed benevolence and was sociable and generous, giving attention to every guest. Hardy came with his lover, helpmeet, secretary and future biographer Florence Dugdale, a woman thirty-eight years his junior who he would later marry, but at that time he was married to his wife Emma. Hardy enjoyed Aldeburgh and 'the sensation of having nothing but the sea between you and the North Pole'.

In 1909, when an operatic version of *Tess of the Durbervilles* was staged at Covent Garden, and Hardy learned that his wife wanted to attend, he asked Clodd to take Florence. He did, and later took her to dinner and escorted her back to her club. He was so taken with her that when Hardy hinted that sea air would benefit her, Clodd invited them down. In August they came for ten days. They went to Cromer in Norfolk and were photographed together beside the breakwater on Aldeburgh beach. They even got stuck on a mudbank in the tidal estuary of the river and had to be rescued. The next year they stayed for five days. When Emma, unaware of the lovers' deception became friendly with Florence, the latter wrote indiscreet and amused letters to Clodd.

In Aldeburgh, Hardy and fellow novelists George Meredith and George Gissing all dined with Clodd. There were others too: Sir James Frazer, author of *The Golden Bough*; Sir Leslie Stephen, author, literary critic and father of Virginia Woolf; and T. H. Huxley, the biologist and advocate of Darwinism. Clodd took them around the lanes of Suffolk in his carriage and on the Alde on his boat, *The Lotus*.

On one occasion the group went to Framlingham, where affixed across the front of a large shop was a sign emblazoned with the words 'George Jude' three times. One of the party, Professor Flinders Petrie, said to Hardy, 'Well, you wouldn't call that Jude the obscure.'

Clodd worried about Hardy's churchgoing, for this was the man who had once described God as 'that Vast Imbecility'. This was a lapse that Clodd never forgave and after Hardy's death he described him as 'a great writer, but not a great character', as if whatever belief Hardy came to was a character flaw.

Hardy grew worried about being seen with Florence and at one point decided that scandal would be more likely avoided if she did not accompany him. So when Aldeburgh was out of bounds for Florence she stayed in Southwold with Florence Henniker, the novelist and daughter of Richard Monkton-Milnes, 1st Lord Houghton, poet and politician, whom Hardy and Emma had befriended two decades earlier. Hardy even saw Florence there when he stayed at the Swan Hotel.

Thomas Hardy – taken sometime between 1910 and 1915, when he knew Edward Clodd.

When Emma died in 1912, and Florence and Hardy decided to marry in 1914 Clodd was one of the first to be told. But that was not the end. Hardy wanted to put behind him the years of deceiving Emma when he was in Aldeburgh with Florence and decreed that there would be no more visits. When he heard that Clodd was writing his memoirs, he had Florence write to say there should be no mention of these trysts, with the threat of action if Clodd disobeyed. He didn't but, unsurprisingly, the friendship faded.

Clodd's first marriage was no less happy than Emma and Hardy's (though Hardy loved his wife, even when he neglected her). When Eliza died in 1911 Clodd confessed that he was pleased to be a widower, and in 1914 when Hardy and Florence married, Clodd married twenty-seven-year-old Phyllis Rope, a student at the Royal College of Science and sister of Margaret Edith Rope (*see* Chapter 6).

In Aldeburgh Clodd wrote his memoirs, lectured widely and wrote much on folklore and the occult. He died on 16 March 1930 at Strafford House, and, as he requested, his ashes were cast out to sea beyond the shoal opposite his home.

Phyllis was living in Aldeburgh near the golf course as late as the mid-1950s (she died in 1957), when Ronald Blythe, the future chronicler of Akenfield, visited her. Soon after she and her companion, Miss Grant-Duff, committed suicide.

Charles Montagu Doughty

Charles Montagu Doughty was born in 1843 at Theberton Hall, Leiston. His background was clerical. He was the second son of Revd Charles Doughty, the local squire of Theberton, and descended from Yorkshire nobility. Three successive Doughty squires had been clergymen.

The Doughtys, whose long association with Theberton is witnessed in the stained-glass windows in St Peter's Church, had acquired lands throughout Suffolk and even more through marriage.

Young Doughty's aristocratic roots might have suggested the freedom to pursue an adventurous career but his place of birth – remote and isolated – would not suggest that this was a man who would one day write *Travels in Arabia Deserta*, only one of several books resulting from his travels in the Middle East

T. E. Lawrence, who is the most obvious parallel with Doughty, is said to have consulted Doughty's books when planning his own travels. It was, he wrote, a 'book not like other books, but something particular, a bible of its kind'.

But his early years, indeed, his early months, were not propitious. Expected to die at birth it, his father baptised him immediately. But it was his mother who died within months of his birth. His father died at the age of fifty-six, when Doughty was six. It was said to have been his mother's death that gave Doughty an abiding sense of bereavement throughout his life. (Within a year of his own marriage, forty-three years later, he was to bury his own stillborn son while his wife fought to retain her health.)

Now orphaned, he and his older brother were entrusted to the care of his uncle and aunt at nearby Martlesham Hall. But uncle and aunt were so uninterested in their responsibility that the boys were packed off to school – Charles to Laleham and then Elstree – and Theberton Hall was shuttered.

Left: C. M. Doughty, *c.* 1908.

Below: Memorial to
C. M. Doughty in
St Peter's Church, Theberton.
(Terry Philpot)

CHARLES MONTAGU
DOUGHTY
Poet and Explorer
1843~1926

Doughty inherited three farms and his father's government bonds, although depreciation of investments affected him later. In October 1864, Henry Hardinge, the vicar of Theberton, wrote to Doughty (who was then at Cambridge University) of his 'researches and noble ambition as regards this earth', and approving his aspiration to 'soar above the vanities of this world and take a place among the worthies who have lived for its adornment and the real glory'.

Doughty's travels took him through Europe and North Africa, Jerusalem, Egypt, Jordan, Syria, and elsewhere. He lived with Bedouin, visited rulers and wrote poetry. He travelled during the Russo-Turkish War and his openly expressed Christian faith and criticism of polygamy and slavery in some places placed him in danger.

Two of Doughty's nephews fought in the First World War, but by then he was too old to fight himself. One – Henry – commanded of the last Dreadnoughts in the main fleet to be built. However, Charles ('Dick') Doughty-Wiley led the 'Horse of Troy' charge at Gallipoli in 1915 and was shot in the head by a sniper. He was awarded a posthumous VC, the most senior officer to be so awarded in that campaign. At the Armistice, despite chaos, bombardment and desecration, his grave was found untouched immediately to the north of Sedd-el-Bahr. His is the only solitary grave on the Gallipoli peninsular.

Sir Ian Hamilton, a Gallipoli commander, said in tribute: 'Doughty-Wylie was no flash-in-the-pan VC winner. He was a steadfast hero. Now as he would have wished to die, so he has died,' and one obituary spoke of a 'staunch, stubbornly honest, and [an] all-too-human hero'.

Doughty was living in Sissinghurst, Kent, when he died in 1926.

Peter Wright VC

There have only been four recipients of the VC from Suffolk (the fifth usually named is Sgt Sidney Day, who was born in Norwich but served with the Suffolk Regiment), but two of them came from the area of Southwold to Aldeburgh.

Twenty-eight years after Charles Doughty-Wylie was awarded his VC posthumously (see above) twenty-seven-year-old Peter Wright, a company sergeant major in 3rd Battalion of the Coldstream Guards, became a recipient.

Most of Wright's battalion officers had been killed by 25 September 1943 near Salerno, Italy, where the battalion assaulting a steep wooded hill was stalled at the crest. He took charge and single-handedly used grenades and a bayonet to silence three German machine gun positions, and then led his men to consolidate the position. Disregarding heavy fire, he beat off a counter-attack and brought up extra ammunition.[1]

Originally awarded the Distinguished Conduct Medal, this was substituted by the award of the VC on the instructions of George VI.

Wright had been born in Mettingham in west Suffolk in 1916. In 1946 he married Mollie Hurren from Wenhaston and together they farmed Church Farm at nearby Blythburgh. He is buried in All Saints churchyard in Ashbocking, north of Ipswich, where he died in 1990.

10. Murders Most Foul

Black Toby at Blythburgh

In the summer of 1750 a detachment of the 4th Dragoons, fresh from action during the War of Austrian Succession, were stationed at Blythburgh to counter local smugglers. They were not popular locally (the East Anglian Regiment had not been deployed as they were not unsympathetic to the smugglers) and there were cases of rowdiness and petty crime. But the men did not like their posting.

When in June the body of a young girl, Anne Blackmore from Walberwick, was found a mile from the village, a coroners' jury found that she had been murdered by a soldier named Tobias Hill. He was a drummer who was nicknamed 'Black Toby' for his dark nature, which emerged when drunk, causing local public houses to ban him. This was in contrast with his usual charming, amiable self.

He pleaded his innocence at Bury Assizes, but there it was said that villagers had come across him the next day in a drunken stupor by the body. He was found guilty and sentenced to be executed on 14 September 1750; his corpse was to hang in chains in a gibbet at the spot where Blackmore's had been found. The gibbet is said to have remained there for half a century until it disintegrated and a local thatcher turned the nails into a thatching comb.

Murder at the Vicarage

Agatha Christie might well have invented the murder of Revd William Farley, the vicar of Cretingham, who had his throat cut by his curate in his vicarage in 1887. The plot, though, might have seemed at first clearer than a Christie invention: the curate Arthur Gilbert-Cooper also lived in the vicarage and it was claimed he was having an affair with Farley's wife Harriet, who was younger than her husband but older than her lover.

Gilbert-Cooper, who pleaded not guilty, had a history of mental illness (he had threatened someone with a knife in the past) and after conviction was sentenced not to hang, but was sent to Broadmoor Hospital for life on the grounds of insanity. He died there in 1927. Harriet Farley left Cretingham and all trace of her is lost.

However, what we now know of the murder belies the comparatively simple facts and is due largely to Sheila Hardy, a local historian. She was told that in 1996 a local carpenter named Henry Mann was working near Aldeburgh to renovate a hunting lodge and came across a plank of wood on which was penciled the words, 'A fearful murder was committed the first day of this month [October 1887] at Cretingham. A curate cut the vicar's throat at 12 o'clock at night.'

Hardy learned more from an octogenarian villager who showed her a collection of contemporary newspaper cuttings that had belonged to her parents. This set Hardy further along the trail of discoveries, which continued after the self-publishing of her book on the subject in 1998 and were revealed later in a commercially published revision.

Harriet, it appeared, had been previously married in 1862 to Captain (later Colonel) William Moule, a man sixteen years her senior, with whom she went to New Zealand, where her husband was involved in suppressing the Maori risings against the colonial government. With his ill health they came back to England, where he died in 1880 aged fifty-three. There is some doubt about the state of the marriage and whether the couple even lived together at the end (there is evidence of an extra-marital affair in New Zealand).

Moule and Farley seem to have met when Farley visited his daughter Elizabeth, in Portsea, Hampshire, where Harriet was living. They were married in London in November 1881, the same year that he had been widowed.

She and her new husband were very different. She was forty, lively and an extrovert; he was older than her with what parishioners called 'a somewhat irascible temperament' and portly – weighing 20 stone when he died.

Upon his death Moule inherited £900. Hardy discovered that, far from having vanished from sight, she was living in Kensington as a companion to an elderly Canadian woman in 1891. By 1901 she was in Liverpool, a 'visitor' in the house of a professor of music. He was originally from Colchester, which raised the question of how long they had known each other.

More significantly, Hardy had doubts about Gilbert-Cooper's guilt but did not dismiss it. For example, believing that he had no blood on his clothes but there was blood on his lover's. Moule's adultery does not make her a murderer, but she may have been, and so might have her mentally ill clerical lover. Or perhaps Farley, distressed at his increasing infirmity, committed suicide? One hundred and thirty years have revealed new information, but not revealed if there is a twist in the plot.

Death Comes to Peasenhall

On the night of 31 May 1902, in the middle of a thunderstorm, a servant named Rose Harsent was stabbed to death in Providence House in Peasenhall – a crime that has never been solved.

Harsent was unmarried but was six months pregnant. William Gardiner, a Primitive Methodist preacher and foreman of the local seed mill, was arrested and tried twice – in 1902 and 1903. A married man with six children, he was said to be the father of the unborn child and it was known that in 1901 they had an affair (it was over by the time of her death), but also that she had more than one lover. Henry Fielding Dickens, lawyer and son of the famed novelist, prosecuted Gardiner at both trials.

In these days before majority verdicts, both juries were hung. Matters were halted when a writ of *nolle prosequi* (unwilling to pursue) was issued, which is not the same as acquittal. Gardiner died in 1941, judged neither guilty nor innocent. However, after a meticulous analysis the writers Fido and Skinner concluded that Gardiner's innocence was 'incontrovertible' but that the case remains 'unsolved and unsolvable'.

The Rye Field Murder

During the Second World War, fourteen-year-old twin sisters Daphne and Brenda Bacon were evacuated to Bedford, coming back to their Leiston home with the war's effective end.

Peasenhall Methodist Church, where William Gardiner preached. (Courtesy of Adrian Cable under Creative Commons 2.0)

On 8 July 1945 Brenda went off on her bike and Daphne told her father she was going for a walk. On the footpath to Aldringham Church she was clubbed; senseless, but not dead, her body was dragged into a field of rye, where it was left by a hedge separating the field from a neighbouring one. She was found by John Mears and a woman called Gee, who both worked for the GPO (he in the Saxmundham branch, and she in the one in Leiston), who had followed a trail of blood.

Meres described how Daphne's face and hands were smothered in blood, her hair was saturated and the tip of one of her fingers was almost severed. He spoke to her while Gee called the police. The police arrived with a Leiston doctor and Daphne was taken to the primary school nearby to await an ambulance. When her father arrived, she told him, 'The man was a soldier.' At 9 p.m. Daphne died as a result of shock from multiple head injuries at Ipswich hospital. She was buried on 20 July.

The flying squad from Scotland Yard was called in and a blood-stained forage cap and footprints were found in the rye field. Local army camps were contacted and men were confined to barracks at the Thorpeness camp. Three days after the funeral, forty-four-year-old gunner Ernest Bailey was charged with murder after a rye ear marked with blood was found in his pocket. He was a single man who had joined the army as a band boy at eleven. He confessed, claiming that he had seen Daphne when out walking, had followed her, and had been possessed of a 'sudden sexual urge'. When she rebuffed

him talking to her he said that he had impulsively hit her several times with a stick from the hedgerow. He also claimed that he was hiding in the rye when Mears and Gee found the body. Despite his confession under interrogation, in his subsequent appearances at Halesworth Magistrates' Court, Saxmundham Magistrates' Court and Ipswich Assizes, Bailey pleaded not guilty.

Dr John Morris, superintendant of the North County Council Mental Colony, attested for the defence that Bailey was 'feeble minded' and suffering from a congenital mental defect with a mental age of nine and a half. He refused to say that the defendant was insane, but the defence counsel asked the jury to believe that what Morris had said satisfied them that Bailey did not know what he was doing at the time.

Bailey was found guilty and sentenced to death, but a few days before the execution was due to take place on 27 November the Home Secretary commuted the sentence to life imprisonment, having considered Bailey's state of mental health and what had been said at the trial.

DID YOU KNOW?

Halfway between Yoxford and Sibton, at a sharp right bend in the road after the bridge, is a track through fields that leads to Deadman's Corner, where two graves were once visible. They were tended until 1942 and then became covered in sugar beet and eroded. When the road subsided, it was discovered that human bones were buried there.

It is said that East Suffolk County Council had the graves turfed in 1902, a century after the bodies were buried there. The claims as to who was buried include two men, one named Rayner, who committed suicide in a house in Yoxford; two travellers hanged for stealing; two men whose ghosts now haunt Darsham Rectory (although it is a woman who is said to haunt that property); two men who shot one another in a duel or possibly quarrelled, with one shooting the other and then hanging himself from an oak tree; and one grave of a man called Danbrook, and other of a man who hanged himself in Martin's Barn, near Willowmarsh Road.

It was reported in *The Times* on 26 June 1801 that Danbrook, 'a respectable shopkeeper', shot himself at the breakfast table in the presence of his wife and a doctor named Rutland. Danbrook was interred by the highway, the newspaper added. The bridge is called Danbrook's Bridge.

11. Signs of Faith

Angel Roofs

When Winston Churchill and kings have lain in state and when Charles I stood trial in Westminster Hall, they were all looked down upon by an angel roof. For centuries, the bowed heads of Suffolk parishioners have looked up from their prayers at the same kind of roofs.

Westminster Hall's angel roof is believed to be the earliest. It was constructed entirely of oak between 1395 and 1398. It is one of the 140 built between 1395, and around 1,530 are estimated to survive in England. The majority date from the fifteenth century and most of them are to be found in East Anglia. Of these, 59 per cent are in Suffolk and Norfolk, with many combining a hammer-beam roof.

Angel roofs are precisely that: a roof adorned with carved angels – some full body, some half-body. A handful of angels are to be found on some roofs, while there are dozens on others, and very occasionally hundreds. The first in East Anglia we can date is in St Nicholas Chapel, King's Lynn. Holy Trinity, Blythburgh, has one of the most

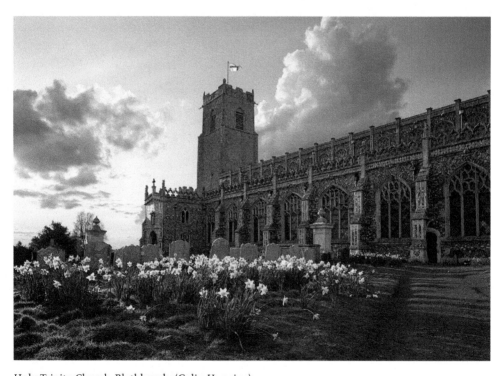

Holy Trinity Church, Blythburgh. (Colin Huggins)

Right: Angel roof at Holy Trinity, Blythburgh. (Courtesy of Amanda Slater under Creative Commons 2.0)

Below: Detail of the roof at Holy Trinity.

magnificent, where calm light falls on pairs of angels – some with their original colouring. It might have been otherwise, but an order in April 1644 by the Puritan soldier and iconoclast William Dowsing that the angels be removed within in eight days was ignored.

Before the Reformation England's churches adhered to the Catholic architectural tradition of devotional statues, stained-glass windows, wall paintings, decorated rood screens, carved figures and doom paintings. As historian Michael Rimmer writes, 'for a largely unlettered congregation, these were the common man's gateway into scripture and the teachings of the Church'.

Under Henry VIII and his son Edward VI, and the later period of Cromwellian iconoclasm, England underwent its own cultural revolution as destructive as that of Maoist China 400 years later. While not the only survivors, the survival of angel roofs was helped by them being far above ground, making them difficult to reach. They are now the largest surviving examples of medieval wood carving.

Such was the size and weight of the roof structure, extremely large timbers were used. Oak was favoured but not exclusively. Most angel roofs would have been made elsewhere and then transported (itself no small task) to the final destination to be fitted (a dangerous job) and finished.

Why are angel roofs so prevalent in East Anglia? Rimmer has come up with what he calls 'a plausible and tantalising possibility'. This is that Hugh Herland was appointed to construct a new harbour at the then thriving port of Great Yarmouth, Norfolk, immediately after he had created the angel and hammer-beam roof of Westminster Hall. It was his last known major job and to work alongside him to forcibly recruit workers were four wealthy local merchants: Hugh atte Fenn, Robert atte Fenn, John de Cleye and William Oxeneye. Rimmer proposes that Herland and his commissioners must have discussed the well-known Westminster Hall project and he had brought with him craftsmen who had worked on it. He and his men would have recruited the best East Anglican craftsmen, men skilled in working on timber construction using large components – carpenters and shipwrights among them. Thus, the combination of discussion, expertise, the knowledge of Westminster Hall, and fashion to be commissioned by the rich (who were patrons of churches) inspired the East Anglian angel roofs once the work in Great Yarmouth was completed. Some of Herland's men may even have stayed to pursue new commissions. Thus, says Rimmer, local fashion, competition between communities, and rivalry among the gentry is why there are so many angel roofs in the area.

Round Towers

As with angel roofs, East Anglia also has a large number of round towers. There are around 181 surviving in England, which are mainly (but not exclusively) found in medieval churches: forty-two of them are in Suffolk and 126 in Norfolk. Those within the hinterland of Southwold to Aldeburgh are St Andrew's Church, Bramfield; St Peter's Church, Bruisyard; St Peter's, Holton; St Peter's, Theberton; St Peter's, Thorington; and St Andrew's, Wissett.

In some cases square towers replaced round ones on grounds of status as a show of affluence. Square towers could hold more bells. We do not know why round towers became so common in Norfolk and Suffolk, but it was probably from the lack of local

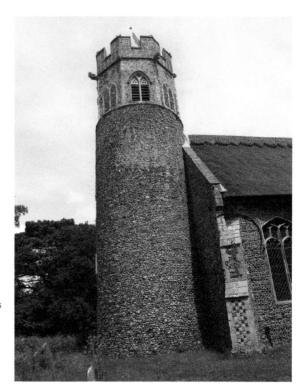

Right: The round tower of St Peter's Church, Theberton. (Terry Philpot)

Below: The round tower of St Peter's Church, Holton. (Courtesy of Adrian Cable under Creative Commons 2.0)

large stone to cut into blocks, which was used elsewhere in England. Stone was more expensive as it had to be imported to the county and shaped by masons and so it was easier to use flint – the locally available material – but, without written records, this is just speculation.

Round towers for churches are thought to stem from the decree of 937 by the Anglo-Saxon King Athelstan, first king of England, that all aspiring to be a 'thegn' (lord of the manor) must build a bell tower on the estate. The towers did not become common until the Normans, which is when building in stone rather than timber became more common. Slightly more towers from this period survive – probably by accident. They rang as a call to service, to prayer, to announce a wedding or a funeral, to accompany a procession, to mark an event, or as a warning. Towers were markers for travellers, and in the Middle Ages they were (with the castle) one of the few stone buildings around.

Non-ecclesiastical round towers have a long tradition reaching back to prehistoric round ritual burial barrows and stone circles. The Greeks and the Romans built round towers too. A round tower can be found at Charlemagne's chapel at Aachen (AD 800), and others in various sites in Italy – such as Ravenna and, of course, Pisa's leaning tower, which was built in the twelfth century.

It has been suggested that minarets were an inspiration for round towers on churches, and they can be found in many parts of the ancient world associated with Zoroastrianism, like Iran and Iraq. Ireland had round belfries dating from the tenth century. France has few round towers, and they can be found in northern Germany, Poland and southern Sweden. Nearer to home, inspiration may have come from the abbey at Bury St Edmunds, which had a rotunda for the martyred saint dating from the early eleventh century.

Round towers continued in use until around 1400, although later ones often had an octagonal belfry. More recently, in Suffolk, round towers have been built at St Stephen's Church, Higham Green, in 1891 by Sir Gilbert Scott, and at St Felix Church, Haverhill, in 2012.

The Wenhaston Doom

St Peter's Church, Wenhaston, contains a treasure that is of interest to more than just specialists. It is a doom painting – a depiction of the Last Judgement – that is believed to have been made and erected by a monk from Blythburgh in around 1480.

Originally thought to cover the chancel arch, it would have looked down upon the worshipping population, warning them of the delights or pains in the life to come. But for most of its existence no one could see it or even knew it was there, for it was covered up during the reign of the Protestant Edward VI – most likely in 1549.

The chancel was shut off from the nave by a whitewashed partition. The partition was removed in 1889, taken apart and put in the churchyard awaiting demolition. However, there was heavy rain in the night and some of the plaster was washed off, revealing parts of the painting.

Fortunately, the Anglicans of St Peter's had more regard then for art and history than Edward's dogmatic followers. They cleaned the partition and when there was a major restoration of the church in 1892 (which revealed stones in the east wall, suggesting at least Saxon origin) it was placed over the entrance to the belfry, but it was later moved to where it can be seen today: on the north wall, just to the left as one enters through the porch.

Above and right: The Wenhaston doom painting. (Terry Philpot)

Doom images were common in the Middle Ages, but an unusual feature in Wenhaston was the attaching of the rood to the painting, with a sculpted figure of Christ on the Cross and the Virgin Mary and St John on either side. There is a space where these figures were once placed.

Beneath the painting are verses from Romans 13 (verses 1–4), which may be Elizabethan. They come from what is said to be an unknown Bible, and may have been added after the Reformation. They read:

> Let every soule submit him selfe unto the authorytye of
> the hygher powers for there is no power but of God the
> Powers that be are ordeyend of God, but they that rest [*sic:* resist] or
> are againste the ordinaunce of God shall receyve to
> them selves utter damnacion. For rulers are not fearefull
> to them that do good But to them that do evyll for he is
> the mynister of God.

Christ in judgement, displaying his wounded hands, is shown on a rainbow. Nearby a scroll states *Venite benedicti* ('Come yet blessed'), while the Virgin and St John pray for mankind. Another scroll near the moon reads, *Discredite mal-editicte* ('Depart ye cursed').

Scrolls are shown to weigh the souls of the departed, with a figure to represent good deeds and devils to indicate the opposite. Satan holds a scroll, which may be an indictment of the accused.

St Peter is there in a cope, wearing the triple papal crown and holding the keys to Heaven. Four saved souls are being received – a king, a queen, a bishop and a cardinal. There is an angel at the gates of each of the heavily castellated mansions to the left, who welcome the souls.

The jaws of Hell are represented on the far right by a fish's head and a swine's snout, while a demon is blowing a ram's horn and figures shown to be in despair are encircled by red-hot chains and being prodded into a chasm. The seven deadly sins are represented and one, which may be lust, is seen carrying a female figure upside down. Five of the dead are rising from their graves to meet their judge.

As we gaze on what to us is a religious curiosity, we should remember that for those who came here in the fifteenth and sixteenth centuries this was a sincere warning of their fate.

DID YOU KNOW?

Holy Trinity, Blythburgh, has a small chapel or priests' room on the first floor above the porch, reached by steep, narrow winding stone steps on the left by the rood screen. This would have been used by the priest to pray for benefactors. It has now been refurbished and reopened for private prayer and meditation.

The priests' room at Holy Trinity, Blythburgh. (Colin Huggins)

John Noyes and the Suffolk Protestant Martyrs

Noyes was a weaver in Laxfield, when on 22 September 1556* he was burned at the stake in the village. He was one of 300 Protestants to be put to death – thirty-four of them in Suffolk – under the reign of Mary Tudor.

Foxe's Book of Martyrs tells us that Noyes was taken to Eye, presumably for trial or examination, and returned to Laxfield at midnight on 21 September. The next day, at the stake, he knelt and said the 50th psalm. Tied up, he exclaimed, 'Fear not them that kill the body, but fear him that kill both body and soul, and cast it into everlasting fire!'

It is reported that Cadman (presumably the executioner) placed the faggot against him, whereupon Noyes gave thanks that he was dying for the truth. The fire was so quick to take that it stifled his last words: 'Lord, have mercy on me! Christ have mercy on me!' His ashes were buried in a pit and all that remained of him – a foot with a stocking – was buried with them.

There appears to have been some popular resistance to the execution: every kitchen fire in Laxfield was extinguished, so the sheriff's men could not find a light to ignite the faggots. One resident, however, forgot and so and the burning went ahead. Such resistance, though, was rare and this is the only example cited by Professor Andrew Pettegree.

There were sometimes shouts of support for the executed, which were severely punished. In Noyes' case John Jarvis of Laxfield called the sheriff's men 'villain wretches'. For this he was sent to the stocks and whipped around the marketplace, while his father and master were each bound over for £5 each to ensure future good conduct.

A plaque commemorating Noyes and his fate is outside the village's Baptist church.

Roger Coe, or Coo, was another martyr who was executed – in Yoxford this time, in August 1555. He was 'a defiant gospeller' according to Eamon Duffy. He stood trial before Bishop Hopton and compared his defiance to that of Shadrach, Meschach and Abednego, who stood against King Nebuchadnezzar.

* This date is according to Eamon Duffy's *Fires of Faith: Catholic England Under Mary Tudor. Foxe's Book of Martyrs* gives the wrong date, saying it occurred in 1557, which is an error repeated on the commemorative plaque in the village.

DID YOU KNOW?

St Edmund's, Southwold, houses the famous Southwold Jack, dressed as a soldier in armour from the Wars of the Roses. He holds a sword and battle axe, and the strikes the bell at the start of most Sunday services.

Southwold Jack, St Edmund's Church, Southwold. (Courtesy of Andrew R. Abbott under Creative Commons 3.0)

William Dowsing

Dowsing was born forty years after Noyes in Laxfield. While the latter died for his beliefs, he would have been pleased to know that Dowsing was able to act on the faith that they shared, albeit with disastrous effects on the heritage of England.

Dowsing's father Wolfran was a well-off local farmer, and his mother Joan was daughter of another farmer in the village. As the youngest son, Dowsing inherited the smaller part of the family estate, but none of it was in Laxfield. He was well educated, probably at a grammar school, and spoke both Latin and Greek. By his twenties he was building up a substantial library, often of illegal works smuggled in from the Netherlands. 'This was a serious collection, and he was a serious man,' avers one biographer.

He and his wife had ten children (she died in 1640 or 1641 and he married again in 1646 and had three more children) and farmed a substantial property in Coddenham and later in the Stour Valley, which might be because Puritanism was popular in that area.

Though he lived to be seventy-two, it was only over fifteen months of his life that this 'grave, earnest, godly man' made a mark on his country that lasts to this day. In 1643 Dowsing had written a letter seeking action against 'blasphemous crucifixes, all superstitious pictures and reliques of popery' in the town and university of Cambridge. In December of that that year, as a widower with children and having been provost marshal of the armies of the Eastern Association (the Parliamentary militias of East Anglia and elsewhere) for only four months, he had a chance to carry out his wishes. He was appointed commissioner to remove the idolatrous and superstitious monuments from all the churches within the Eastern Association.

Dowsing went about his work with enthusiasm to 'cleanse' most of the churches of Cambridgeshire, and, working with least eight deputies (some of whom lived near him and several of whom were related to him by marriage), he 'cleansed' most of those in his native county. In his extensive iconoclasm – he also worked in Essex and south Norfolk – he stands alone. This is because while it was not uncommon for soldiers to take it upon themselves to desecrate churches, after August 1643 and May 1644 the work was given by to churchwardens Parliament, with his own appointment being *ultra vires*.

His work is well known from the notes he took and then wrote up in a journal. The journal was ultimately lost, but not before entries were published by local antiquaries – county by county. He recorded visits to 147 parishes in Suffolk alone, a third of the total.

The destruction was beyond any caution. Chancels were levelled and altar rails were removed, as were inscriptions from tombs or in glass that invited prayers for the souls of the dead. Water stoops, organs and all representations in wood, stone and glass of the Trinity or the heavenly host fell to the iconoclasts' tools. The size of the task eventually caused some finer focus, thus any visual distraction for the worshipper or representation of the communion of saints did not escape. But Dowsing was not only supervisor and recorder, he took to the work with gusto.

We know that Dowsing believed his work was on the command of God and ensured that the Parliamentary armies would be victorious in battle. But in the middle of 1644 doubt in the Puritan cause began to show, as divisions arose and there were abuses of liberties. This led him to withdraw from public life, which was made no easier toward the end of his life by disputes between the children of his two marriages. He died in 1668, eight years after the monarchy's restoration.

DID YOU KNOW?
The painted figures of the rood screen at St Edmund's Church – angels on the left, apostles in the centre, and the Old Testament prophets on the right – all have their faces missing. As in other churches in Suffolk and elsewhere, these were hacked out by Cromwellian iconoclasts, rooting out what they considered was idolatry. The original font, positioned at the other end of the church, suffered the same fate.

St Edmund's Church, Southwold. (Courtesy of Andrew R. Abbott under Creative Commons 3.0)

Bibliography

As always, the *Oxford Dictionary of National Biography*, one of the world's greatest reference works, has proved indispensable. In researching and writing this book, I have also read or consulted the following publications:

Ackroyd, Peter, *Wilkie Collins* (London: Vintage, 2013).

Blythe, Ronald, *Aldeburgh Anthology* (Snape and London: Maltings Foundation in association with Faber Music, 1972).

Blythe, Ronald, *Borderland: Continuity and Change in the Countryside* (Norwich: Canterbury Press, 2007).

Blythe, Ronald, *The Parish Church of St Peter & St Paul, Aldeburgh* (Aldeburgh: Church of St Peter & St Paul, 1974).

Blythe, Ronald, *The Time by the Sea: Aldeburgh 1955–1958* (London: Faber & Faber, 2013).

Bowker, Gordon, *George Orwell* (London: Little, Brown, 2003).

Bridcut, John, *Britten's Children* (London: Faber and Faber, 2011).

Carpenter, Humphrey, *Benjamin Britten: A Biography* (London: Faber & Faber, 1992).

Chant, Katherine, *The History of Dunwich: The Amazing Story of a City Lost to the Sea* (Dunwich: Dunwich Museum, 2011).

Clark, Kenneth, *Another Part of the Wood: A Self-Portrait* (London: Hamish Hamilton, 1985).

Clodd, Edward, *Memories* (London: Chapman and Hall, 1916).

Collier, Peter, and Horowitz, David, *The Kennedys: An American Drama* (London: Pan Books, 1985).

Collins, Ian, *A Broad Canvas: Art in East Anglia Since 1880* (Norwich: Black Dog Books, 1999).

Crawford, Alan, *Charles Rennie Mackintosh* (London: Thames & Hudson, 1995).

De Lisle, Leander, *The Sisters Who Would be Queen: The Tragedy of Mary, Katherine and Lady Jane Grey* (London: HarperPress, 2008).

Duffy, Eamon, *Fires of Faith: Catholic England Under Mary Tudor* (New Haven, Conn. and London: Yale University Press, 2009).

Elliott, Gill, *Hidden Suffolk* (Newbury: Countryside Books, 2000).

Engel, Matthew, *Engel's England* (London: Profile Books, 2014).

Fawcett Garrett, Millicent, *What I Remember* (London: T. Fisher & Unwin, 1924).

Filmer-Sankey, William, and Pestell, Tim, *Snape Anglo-Saxon Cemetery: Excavations and Surveys 1824–1992* (Ipswich: Suffolk County Council, 2001).

Fido, Martin, and Skinner, Keith, *The Peasenhall Murder* (Stroud: Alan Sutton Publishing, 1990).

Fitzgerald, Penelope, *The Bookshop* (London: Flamingo, 1989).

Gardham, Jane, 'Obituary: Maggie Hemingway', *The Independent*, 16 May 1993.

Grenfell, Joyce, *Letters from Aldeburgh* (edited by Hampton, Jane). (Charlburgh, Oxon: Day Books, 2006)

Hardy, Sheila, M., *The Cretingham Murder* (Stroud: The History Press, 2008).

Hemingway, Maggie, *The Bridge* (London: Jonathan Cape, 1986).

Hogarth, D. G., *The Life of Charles Doughty* (Oxford: Oxford University Press, 1928).

Holt, Ysanne, *Philip Wilson Steer* (Bridgend: Seren Books, 1992).

James, P. D., *Time to be in Earnest: A Fragment of Autobiography* (London: Faber & Faber, 1999).

Jones, J. D. F., *The Storyteller: The Many Lives of Laurens van der Post* (London: John Murray, 2001).

Kerr, Gordon, *Charles Rennie Mackintosh: Masterpieces of Art* (London: Flame Tree Publishing, 2014).

Laughton, Bruce, *Philip Wilson Steer* (Oxford: Clarendon Press, 1971).

Lee, Hermione, *Penelope Fitzgerald. A Life* (London: Chatto & Windus, 2013).

Lycett, Andrew, *Wilkie Collins: A Life of Sensation* (London: Windmill Books, 2014).

Knights, Sarah, *Bloomsbury's Outsider: A Life of David Garnett* (London: Bloomsbury Reads, 2015).

Manton, Jo, *Millicent Garrett Fawcett* (London: Methuen & Co., 1965).

McKean, John and Baxter, Colin, *Charles Rennie Macintosh: Architect, Artist, Icon* (Edinburgh: Lomond Books, 2000).

Mitchell, Lawrence, *Suffolk* (Chalfont St Peters, Buckinghamshire: Brandt, 2014).

Moffatt, Alistair, *Remembering Charles Rennie Mackintosh: An Illustrated Biography* (Lanark: Colin Dexter Photography, 1989).

Myers, Jeffrey, *Orwell: Life and Art* (Urbana, Chicago: University of Illinois Press, 2010).

Pettegree, Andrew, *Marian Protestantism: Six Studies* (Aldershot: Scolar, 1996).

Rimmer, Michael, *The Angel Roofs of East Anglia: Unseen Masterpieces of the Middle Ages* (Cambridge: Lutterworth Press, 2015).

Rouse, Michael, *Southwold to Aldeburgh Through Time* (Stroud: Amberley Publishing, 2012).

Scarfe, Norman, *The Suffolk Guide* (Bury St Edmunds: The Alastair Press, 1988, 4th edition).

Scott, Richard, *The Walberswick Enigma. Artists Inspired by the Blyth Estuary* (Ipswich: Ipswich Borough Council, 1994).

Schenkar, Joan, *The Talented Miss Highsmith: The Secret Life and Serious Art of Patricia Highsmith* (New York: St Martin's Press, 2009)

Stourton, James, *Kenneth Clark: Life, Art and Civilisation* (London: William Collins, 2016).

St Peter's Church, Wenhaston, Suffolk, *Guide* (Wenhaston: St Peter's Church, 2002).

Taylor, Andrew, *God's Fugitive: The Life of Charles Montagu Doughty* (London: HarperCollins Publisher, 1994).

Thompson, Roger, *Mobility and Migration: East Anglian Founders of New England 1629–1640* (Amherst, Mass: University of Massachusetts, 1994).

Tomalin, Claire, *Thomas Hardy, the Time-torn Man* (London: Viking, 2006).

Walberswick Local History Group, 'Black Toby', Newsletter No. 44, September 1913.

Wilson, Andrew, *Beautiful Shadow: A Life of Patricia Highsmith* (London: Bloomsbury, 2004).

'Forgotten Authors No. 16: Margery Sharp', *The Independent on Sunday*, 30 November 2008.

Acknowledgements

As well as the efficient and helpful staff at the British Library, many others have assisted me in various ways in researching and writing this book and require acknowledgement and thanks.

Dr Darren Clarke, Rausing Head of Collections, Research and Exhibitions, for the Charleston Trust supplied the photograph of Duncan Grant; Elizabeth Crawford, research volunteer at the Charles Rennie Mackintosh Society, suggested reading and read the entry on the painter; Colin Huggins took the photographs of Holy Trinity, Blythburgh; Simon Ilett, churchwarden of St Peter's, Theberton, gave me information on the German servicemen killed when the Zeppelin crashed and where they now rest; Lyn Stilgoe, secretary of the Round Tower Churches Society, advised me on 'her' subject and read the entry; Ruth Proctor, town clerk of Aldeburgh Town Council, told me the story of the fate of the statue of Snooks, while Catherine Howard-Dobson, volunteer curator, Aldeburgh Museum, explained which of the two statues is where; David Matthews confirmed the story told to his late partner, the novelist Maggie Hemingway, about the putative child of Philip Wilson Steer and also of how she felt she had 'come home' when she crossed the River Stour; Ella Roberts, communications manager of the Britten-Pears Foundation, supplied the photographs of The Red House, Aldeburgh on page 47, of Imogen Holst on page 48 and Benjamin Britten and Peter Pears on page 44, as well as clarifying Mary Potter's connection with The Red House; Arthur Rope read the entry on his remarkable artistic family; Amy Taylor, media officer of the Landmark Trust, supplied the photographs on page 19; and David Weight, church guide of St Edmund's, Southwold, clarified facts about the fifteenth-century fire in the original thirteenth-century chapel and about Southwold Jack. Last, Alan Murphy of Amberley Publishing commissioned this book and Becky Cousins, assistant editor, helped see it to press.

Also available from Amberley Publishing